Classic Restaurants

OF

OKLAHOMA CITY

Classic Restaurants
OF
OKLAHOMA CITY

······················· DAVE CATHEY

AMERICAN PALATE

Published by American Palate
A Division of The History Press
Charleston, SC
www.historypress.net

Front cover, top left: photo courtesy Oklahoma Historical Society; top middle: photo courtesy Oklahoma Historical Society; top right: photo courtesy Rick Bayless; bottom: photo courtesy Kyle Anderson. Back cover: photo courtesy the Oklahoman; *insert: photo courtesy John Bennett.*

First published 2016

Manufactured in the United States

ISBN 978.1.46711.921.4

Library of Congress Control Number: 2016947532

Notice: The information in this book is true and complete to the best of our knowledge. It is offered without guarantee on the part of the author or The History Press. The author and The History Press disclaim all liability in connection with the use of this book.

CONTENTS

Acknowledgements 7
Introduction 9

PART I: FROM BIRTH TO BAD TO WORSE 11
 1. Downtown Endurance 13
 2. Waffles Show the Way 21
 3. It's the Sauce! 27
 4. Specialty Dining 31
 5. From Dubious Beginnings 39

PART II: EVERYTHING GOES BOOM 43
 6. Hard Six to Easy Chair 45
 7. The Legend of Sleepy Hollow 49
 8. The Cafeteria Capital of the World 53
 9. Outranking the Colonel 67
 10. Flavors of the World 71
 11. From the Pits to Great Heights 83
 12. Breeding Ground for Hoodlumism 91
 13. Enduring Diners 97

PART III: CULTURES BLOSSOM, BOOMERS FINALLY BUSTED 103
 14. Fine Dining Takes Shape 105
 15. Variety Is the Spice of Life 121
 16. Burgers and Sandwiches 129

CONTENTS

17. Global Cuisine 135
18. Home Cookin' 143

PART IV: BUST TO BOMBING TO BIG LEAGUE CITY 149
19. Cattlemen's Café to Cattlemen's Steakhouse 151
20. The Theater of Dining 155
21. Laissez les Bon Temps Roulez 159
22. From Nino's to Chelino's 163
23. Rise of the Asian District 165
24. The Next Wave 169

Notes 173
Bibliography 177
Index 181
About the Author 189

ACKNOWLEDGEMENTS

This book was almost as labor-intensive as it was rewarding. It is about heroes of hospitality, but this project required its own heroes, starting with the team at Arcadia/The History Press, who stuck with me through what at times felt like a dogfight with fate. Special thanks to Candice Lawrence for her patience and diligence and Rick Delaney for his meticulous editing. But the biggest heroes were my wife and kids, who somehow managed to survive incessant conversations about long-gone cafeterias, burger and barbecue joints, pizza places and tearooms for the better part of the nine months it took to gestate and bear this book. Thanks Lori, Luke and Kate. I love you.

Special thanks to the Oklahoma Historical Society's Rachel Mossman, Bob Blackburn at the Oklahoma History Center, the *Oklahoman*'s archivist Linda Lynn and the support of my editors Matt Price, Clytie Coppell and Kelly Dyer Fry. Without the volumes of coverage provided by the *Oklahoman* and *Oklahoma Times* from people like Ivy Coffey, Ann DeFrange, Max Nichols, John Denton, Tricia Pemberton, Melba Lovelace and Robert E. Lee, this book wouldn't have been possible. I also relied on coverage from our other fine local publications, where I count many friends at the *Journal Record* and the *Oklahoma Gazette*. Thanks also to Becky Rickard, historian for Sonic Drive-ins. And a special thanks to chef John Bennett, local restaurant historian and catering ace Kyle Anderson and faithful reader and friend Glen Cosper for their contributions.

Finally, thanks to the hundreds of readers who contacted me to share their stories about dining in Oklahoma City.

INTRODUCTION

C overing Oklahoma City dining since 2008 has afforded me the chance to cross paths with a motley group of dedicated professionals. No two operators have the same back story, but they share a common goal: delivering memorable flavors in a hospitable setting. It's a good thing they also share an otherworldly work ethic, because that's what it takes to have any chance to survive as a restaurateur.

But that work ethic is only the foundation. To succeed takes timing, determination and skill. In compiling this book, I didn't have the space to recount every success story in the history of Oklahoma City dining. That would've taken a volume five times larger than this.

For this book, I've tried to focus on the enduring names of Oklahoma City dining. What I found is that to endure in this business, and probably any other, a concept must be able to evolve. In some cases, evolution is subtle, but other establishments have endured thanks to wholesale changes. In the end, the hearts and minds behind that evolution have found a way to connect with the hearts and minds of their diners.

In researching this book, numerous stories were unearthed that I plan to share in my capacity as food editor at the *Oklahoman* and aggregate online (www.theoklahoman/dave-cathey). While I wish each great story could've fit in these pages, I look forward to sharing even more over the years to come.

Long before Kurt Fleischfresser established an apprenticeship program at the Coach House, a tiny woman from Kansas developed a system of operation to support an ambitious idea to turn cafeteria dining into an

occasion. And when it succeeded, she courageously embraced those who followed her lead as colleagues rather than competitors. The result was an unprecedented affinity for cafeteria dining that Oklahoma City diners showed for nearly a century in close to forty locally founded concepts that served the community for a combined three-hundred-plus years.

Luis and Maria Alvarado began a similar pay-it-forward mentality in 1937 when they opened El Charro, which would evolve into El Charrito and become the seed from which the vast majority of the city's Mexican restaurants would grow.

Beverly Osborne would survive the Great Depression by striking gold with an idea to franchise fried chicken to save his fledgling waffle shop and grow into a nationwide operation that would land him in *Time* magazine. But Osborne didn't take his secrets to the grave, partnering with Randy Shaw in the 1950s while having a hand in "at least 50 restaurants" during his career.

These pages will not, nor could they, document every restaurant that ever opened in Oklahoma City. Space constraints won't even allow it to share every detail of every historic restaurant that ever existed in Oklahoma's capital city. The book focuses on the places—and the people behind them—that earned their way into history through excellence, endurance and legacy.

Part I
FROM BIRTH TO BAD TO WORSE

Chapter 1

DOWNTOWN ENDURANCE

A hodgepodge of opportunity seekers and carpetbaggers came to the prairie as Oklahoma City was forming. Pushcarts and nondescript structures promising a hot meal were among the first to sell food for profit in town. As statehood arrived and the capital moved, the city's first enduring eateries opened.

KAISER'S

Kaiser's makes the best ice cream in the world!
—Chef John Bennett, to the wedding party for Phila Cousins,
Julia Child's niece, in Sausalito, California, mid-1970s

Kaiser's Ice Cream is probably the most enduring brand in local dining, but its popularity is related almost solely to the quality of the product. Founder Tony Kaiser didn't conjure the magical recipes for the iconic ice cream, nor did he ever fully realize its potential as a business, but the public's love for the product has kept it alive for more than a century.

Kaiser opened his establishment in 1910, a time when dining options were primarily limited to breakfast, sandwiches, hamburgers, steaks, cutlets, frankfurters and the occasional oyster loaf.

The grandson of a famous purveyor of baked goods and confections in Chur, Switzerland, Kaiser left Europe the same year Sooners ran roughshod

over open prairie in Oklahoma. But Kaiser's new life in the United States began in Dubuque, Iowa, before he followed so many others to chase the promise of the up-and-coming prairie town shortly before it became the state capital.

Kaiser brought with him fifty cents, a three-quart ice cream freezer and secret family recipes and formulas for ice cream. He put the Kaiser tradition to work after buying a bankrupt ice cream parlor at Northwest Seventh Street and Robinson Avenue. The recipes came from the aforementioned grandfather who, Kaiser's wife, Gladys, said was Switzerland's first commercial baker and confectioner.[1]

In 1918, the store moved to what is now Midtown on a roundabout where Northwest Tenth Street meets Walker Avenue. Kaiser's carried thirty-six flavors plus seasonal choices. It was no surprise to see a dozen or more cars wrapped around the shop awaiting curb service. And when people couldn't make it to the Classen Circle, ice cream was packed in salted ice, loaded in the back of a Model A Ford and delivered.

Kaiser sold sandwiches, hamburgers, franks, quiches, salads and soups plus handmade malts, shakes and sodas. Specialties included "every variety

Kaiser's Ice Cream moved to its final location in 1918, a year after opening. *Courtesy Shaun Fiaccone.*

of wedding mold in all the perfect varieties of delicious Kaiser's Ice Cream," as well as fresh bakery goods. Kaiser was a gifted ice carver known for exotic punches, ice creams and frozen puddings. Gladys Kaiser described a peach ice cream he'd made in a peach mold that even included a pit her husband made out of chocolate.

Kaiser was also known in the early 1920s for keeping a pair of watchdogs. In a 1926 article, he told a reporter, "If these druggists and other merchants in the residential districts would place good dogs on guard at night, I think a lot of this burglary would cease. I am certain that persons have entered my store with the intention of sticking me up and have thought better of it after a look at my dogs."[2]

Kaiser was so confident in his dogs that he didn't carry burglary insurance. He said in the five years he'd employed the dogs, the filling station across the street was robbed twelve times while he hadn't been assailed once. The dogs spent nice days on the roof, which afforded them ample room for exercise, but they spent their evenings inside. Kaiser trained the dogs not to accept food or attention from anyone but himself. He even used the dogs to babysit his children in a pinch.

After Kaiser's death, his son took over briefly before illness befell him and the store found itself on the brink of bankruptcy. It was purchased in 1977 by Larry Burke, who breathed new life into the concept and ended up expanding. Burke caught a surge in demand for gourmet ice cream that saw expansion for Baskin and Robbins and the introduction of Häagen-Dazs stores into Oklahoma City. Kaiser's opened new spots in Nichols Hills, east of Quail Springs Mall by the old AMC movie theater and all the way to Dallas. By 1990, the trend had fizzled, and Burke set about closing stores, the one in Nichols Hills becoming the home of Mamasita's, which it remains today.

Local attorney Peter Schaffer eventually bought the property and converted Kaiser's into the Grateful Bean, which served ice cream, sandwiches, health food and burgers while training the marginally and chronically unemployed from 1994 to 2004. It closed for a couple years and then reopened and operated until 2010. The space was then leased to Picasso's Café owners Shaun Fiaccone and Kim Dansereau, who converted it into Kaiser's American Bistro. That concept lasted until 2014, when Kristen Cory, Angie Uselton and Randy Giggers took over the lease and rebranded the space as Kaiser's Diner and Ice Cream Parlor. In spring 2016, the space returned to Schaffer, who reopened under the Grateful Bean, the Kaiser's signage as prominent as ever.

Coney Island

Bill Mihas still serves hot "wieners" and plays chess with regulars every Saturday at Coney Island Hot Dogs in downtown. The walls are adorned with the ghosts of University of Oklahoma football seasons past, and Coney Island sells old-fashioned coneys with Greek chili as it did when the Soter brothers finally settled at 404 North Broadway in 1928. Two years earlier, James Soter first tried to open a hot dog stand called Coney Island in Tulsa. The problem was, Tulsa already had a place by that name, and Soter lost a lawsuit over use of the name. So he tried, unsuccessfully, to do the same in Amarillo, Texas, and again back in Tulsa (under a different name) until fate took him and brothers Mike and Gus to downtown Oklahoma City. They closed for a while during the Great Depression and again briefly in 1953, but the business sustained the Soters, with the help of Kate Samaras-Soter in the 1940s, until the family sold the business to fellow Greek immigrant Mihas in 1966. Mihas serves the same chili-cheese coneys, chili, Frito pie and chili spaghetti plus chips, soda and beer he has since he took over.

After the Soter family sold its business in the Midwest Building to Mihas, he eventually moved into the old Colonial Hotel in 1974. When Mihas purchased the old Bill's Hot Dogs in Capitol Hill, he needed an operator, so he summoned his wife Mary's brother Dimitrios Smirlis to take over Coney Island No. 2 on the southeast corner of Commerce and Harvey.

Lunchtime at the Coney Island No. 2 attracts a moving line of customers along the serving counter. The decor is basic and clean, with a slim serving counter that features an antique cash register. Utilitarian metal tables are arranged close together, and one wall is covered with the same handwritten posters listing the University of Oklahoma football records back to the 1971 season that are displayed downtown. The diner has never advertised, but "regulars" eat at the Coney Island several times a week.

THE QUEEN

*My favorite place was the Anna Maude Cafeteria when it was still downtown.
When my sister and I were young, my mother made it a special treat to take us,
one at a time, out for a day of shopping and time with just her. We always ate
at Anna Maude's. This has always remained special, and we still went there for
special dinners with our mother until it was closed.*
—*Dixie Cassar, Oklahoma City, 1999*

The most important restaurant in early Oklahoma City was the cafeteria
inside the downtown YWCA. It opened on May 31, 1919, and was operated
by a young lady born in 1886 in Case, Kansas, named Anna Maude Smith.
Folks would come to call her the Cafeteria Queen, but that's selling her short.
While Smith surely is one of the most pivotal figures in Oklahoma City
dining history, she is also among a small class of influential businesswomen
in the city's annals.

Anna Maude came to town with a college degree, five years of exemplary
work from Kansas to New York City and plenty of early-life obstacles
to trigger an inexhaustible work ethic. Anna Maude's mother died
unexpectedly in 1909, forcing the twenty-three-year-old Smith to run her
family's household. After she left for Kansas State College (now University),
her father fell ill and was left an invalid, drawing Anna Maude home again.
When she finally earned her degree in home economics in 1914, Anna
Maude's initial interest was fashion.

"I wanted to be a dress designer, but then a lot of people care more about
what they eat than what they wear," Smith said in 1978.[3]

Smith's first job was working for free at the YWCA in Des Moines, Iowa,
"to build experience." Next she managed a second-floor, walk-up tearoom
in Leavenworth, Kansas. That led her to Fort Wayne, Indiana, where
she turned a floundering YWCA cafeteria into a success. That drew the
attention of the YWCA's national office in New York, which called her east
to train employees and supervise several large cafeterias. But the "pint-sized
dynamo" became homesick.

"There were lots of offers, mostly from the eastern states, but I was a
girl from Kansas, and I just didn't want to live in the East," she said in an
interview published in the July 16, 1978 edition of the *Oklahoman*. "Then
there came a call from Oklahoma City. They needed a manager for their
YWCA cafeteria. I had never been in Oklahoma City before, but I thought
it was close enough to Kansas for me."

Anna Maude Smith was known as the Cafeteria Queen. *Photo courtesy Oklahoma Historical Society.*

Smith came to Oklahoma City to open the YWCA cafeteria in 1919 and proved to be much more than a good cook. Long before the notion of social media, Anna Maude Smith understood the power of socializing and the outstanding tool she could make of media. Less than a month after opening, Smith used the *Daily Oklahoman*'s June 26, 1919 public records to report that the YWCA cafeteria had served "719 people on Tuesday, a number only surpassed by the opening day and the occasion when the Thirty-Sixth Division showed up to eat" and "chicken feasts on Wednesday and Saturday nights."

In 1928, she leased the basement of the Perrine Building and gave Warren Ramsey a $100 budget to design, construct and furnish the first dining room for what would become the Anna Maude Cafeteria. The result so reflected

Smith's vision that she would never use another designer, nor would her successor, Cooper Lyon. When Anna Maude Smith and her partners opened on July 16, 1928, it was a harbinger for the next six decades.

"I don't remember too much about the first day because I was so busy," Smith said fifty years later.[4] "Someone brought me a huge bouquet of flowers, and all I could do was hand it to my assistant. I was too busy for flowers that day."

Smith introduced double serving lines and advertised foods chosen and prepared by trained dieticians, dishes cleansed "in the scientific manner" and "new chilled, washed air."

The place was open from 11:00 a.m. to 2:30 p.m. for lunch and 5:00 to 7:45 p.m. for dinner. In 1938, Smith and Ramsey renovated the dining room with Swedish modern decor. Menus were planned by the week, which might include making 18 gallons of vegetable soup using all fresh ingredients, 80 cakes, 324 pies, 350 pounds of peeled potatoes, 10 hams, 160 pounds of beef and 100 pounds of butter. When food rationing threatened local restaurant operations during World War II, Smith's operations expertise was put to the test, and she survived, the leaner and stronger for it.

"I never lowered the quality of the food, even during the Depression and World War II. When a recipe called for butter, that's what we'd use."

That attention to detail and refusal to lower standards was the key to her success in battling all comers, including an influx of

Anna Maude Smith started with the YWCA in 1919. *Photo courtesy Oklahoma Historical Society.*

outside competition her success bred. The Michaelis Cafeteria of Tulsa opened in 1930, taking over the three-story space at 219–221 West First Street where Montgomery Ward had recently left. The multilevel Britling arrived from Alabama soon after; Luby's, founded in 1932 in Texas, was not far behind.

When Arthur Crump came home from the army in December 1945, after serving four years in World War II, he hoped to get his old job back at the Anna Maude.

"The man who replaced me happened to be at the train station the day I came back," Crump said. "He told Anna Maude, and she called my home before I got there. She told me to come back to work, and she gave me $200 to get through Christmas."[5]

Crump kept the job another five decades.

Chapter 2
WAFFLES SHOW THE WAY

Two of Oklahoma City's most beloved restaurants, Bishop's and Beverly's, began as waffle houses before building a fortune for their owners.

BISHOP'S

They made the very best chicken pot pie and oyster stew.
—Jo Gentry, 1999

Bill Bishop was pushing his string of successful diners, Kansas City Waffle House, across Oklahoma before the Roaring Twenties and as far west as Santa Fe, New Mexico, by the Great Depression. His Bishop's Kansas City Waffle House No. 5 opened at 113 North Broadway Avenue in 1925. But in 1930, Bishop took a chance that Oklahoma's oil industry would support a more ambitious concept. No. 5 became Bishop's Restaurant in 1933. It quickly became the setting for first dates, anniversaries and special occasions while maintaining brisk services for customers of lunch and dinner to dine on the Brown Derby Steak with French fries or onion rings, grilled onions and hot rolls light as clouds. A meal like that cost sixty-five cents, and a steak platter for two was featured at $1.85 shortly after World War II.

In 1944, Bishop's became the first stop in Judy Willis's fifty-four-year career waiting tables. She stayed with Bishop's until the late 1950s. "My

biggest thrill was being chosen to serve President Eisenhower when he ate in the VIP Room. He was so sweet and down-to-earth. He had five bodyguards, nice but very strict."[6]

Bishop's closed in 1969.

BEVERLY'S

The rest is just boiled in oil.
—Beverly Osborne, 1979

When the sign at the Hunt's Waffle Shop on Main Street changed to Osborne's Waffle House on December 7, 1921, nobody in Oklahoma City could've guessed that the new proprietor would use the six-stool café to launch a concept that eventually would have three hundred fried chicken franchises nationwide—two decades before Harland Sanders donned a white suit.

The little man with enormous vision and epic work ethic was named William Beverly Osborne. Born in College Mound, near what is now Bray in Grady County, Osborne was the oldest of seven children of a sharecropper, whose income couldn't sustain nine. So sometime after his eighth birthday, Osborne marched barefoot to the county seat of Marlow, carrying a box that contained the shoes he didn't want to wear out on a six-mile walk and a clean pair of skivvies. He had thirty cents in his pocket, which he parlayed into a fortune selling pancakes, fried chicken and hamburgers at a restaurant that would outlive its founder by more than three decades.

Osborne begged his way into a Main Street barbershop that shared space with a small café. When Osborne was told he couldn't make any money shining shoes at the barbershop, he retorted, "I can do as good as I'm doing now."[7]

He spent his first night in Marlow sleeping on towels on the barbershop floor. When the restaurant opened in the morning, he spent a nickel on a piece of pie for breakfast. About a month later, he started working for it, earning $2.50 a week washing dishes. Osborne learned to cook, run the register and serve the counter in the year he worked there.

When he was ten, Osborne heard about a new drugstore opening in Comanche and paid a visit to the owner, who would prove dubious of hiring Osborne thanks to his age. So Beverly hooked up the soda

Beverly Osborne and one of his waitresses outside his Lincoln Boulevard location. *Photo courtesy Kyle Anderson.*

fountain's carbonation system and declared, "You can fire me if you don't want me to stay."

Osborne spent the next four years working at the drugstore.

"I was getting five dollars a week, and I paid four dollars for a room at the hotel," he said.

By age sixteen, Osborne had enough money to put about thirty dollars down on one of the first horseless carriages that folks in Comanche ever saw, but he didn't buy the car strictly for transportation.

"I rented it out and began to make a little money."

He charged Comanche youth a dollar an hour for weekend joyriding.

"Later, I bought a better car and rented it out, too."

Osborne moved back to Marlow to court Rubye Massey and work as a soda jerk. After a few weeks, Osborne offered to trade his Dodge touring car to the druggist if he would move the soda fountain to Comanche, which he did. Osborne opened a confectionary, using the soda fountain to draw crowds. In November 1917, Rubye Massey became Rubye Osborne, despite her father's prognostication that her new spouse would never amount to more than a soda jerk. Beverly and Rubye worked side by side and remained married sixty years until she died in 1977.

Soon Rubye, who would become known for her poetry later in life, was running the soda fountain while her husband bought cars and resold them in oil-rich Burkburnett, Texas.

"Selling cars was like selling hotcakes," he said.

In 1920, the Osbornes sold his Comanche confectionary for $3,500. Soon after, they drove their new Chandler to Oklahoma City for a weekend getaway. While there, they ate at Hunt's, where two pancakes and a cup of coffee cost fifteen cents. Whether it was the quality of the pancakes and coffee or some opportunity Osborne saw in the place is unclear, but the young entrepreneur couldn't get Hunt's out of his mind.

"I said, 'Let's go to Oklahoma City and buy that little restaurant by the Orpheum Theater.'"

It took borrowing money against his car, pawning Rubye's wedding ring and borrowing fifteen dollars from the milkman for change to do it, so that's what the Osbornes did. Beverly cooked and washed dishes while Rubye hopped the counter. Pretty soon, Osborne squeezed a seventh stool into the Waffle Shop and added eggs and bacon to the menu.

Osborne's stayed open until "midnight or 1 a.m." every night, which necessitated hiring his two brothers to run the night shift. The menu

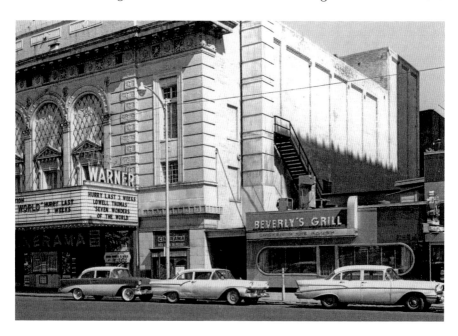

The original Beverly's Grill was wedged between the Colcord Hotel and a movie theater. *Photo courtesy Oklahoma Historical Society.*

expanded with fifty-cent dinners and the "Osborne Famous Filet Mignon Steak." By 1928, one could expect to choose between baked pheasant with apple or barbecue chicken with sage dressing for fifty cents.[8] Osborne opened his eighth waffle shop in 1931. The new place was a departure from his seven-stooled original and the seven succeeding spots. An advertisement in the *Daily Oklahoman* announcing its opening read:

> *The eighth link is added to the chain of Osborne's Waffle Shops in the opening of another new and distinctive eating place at 111 North Robinson. A chain welded by quality foods and exceptional service at moderate prices. The formal opening is announced for Monday. Special menus have been prepared for the day. There will be flowers for the ladies and smokes for the men from 11:00 a.m. to 2:00 p.m. and 5:00 p.m. to 9:00 p.m. This beautiful new shop of Spanish design has a particular appeal to the business woman. The linotile counter of unique design with its comfortable Spanish red leather chair-back stools accommodates twenty patrons. The mezzanine floor affords more leisurely dining with its table service for fifty.*

Timing was poor, thanks to the ongoing implosion of the U.S. economy. Osborne began selling off his stores, trimming down to the original spot between the Orpheum Theater and the Colcord Hotel in 1935. In order to build out the tiny spot to the 125-seat capacity it would grow to, Osborne needed inspiration and would find it on the way west.

As the Dust Bowl blew over large portions of Oklahoma's population, the Osbornes decided to take a trip to California themselves, seeking inspiration or perhaps even a new beginning. Out on Route 66 in a Model T Ford pickup, Rubye reached for a basket of fried chicken and biscuits she had packed for the journey. Neither roads nor tires were yet up to today's standards, so eating in the car was no simple proposition. When the bumpy conditions caused Rubye's chicken to tumble to and fro, she proclaimed, "This really is eating chicken in the rough!"

The Osbornes saw plenty on their westward sojourn, but Beverly couldn't shake the words that had rolled off his wife's tongue: "Chicken in the rough." When they returned, Osborne bought a small drive-in with four booths and nine stools at 2429 North Lincoln Boulevard and called it Beverly's Drive-In. The concept was a phenomenon. Within months, the Osborne's Waffle Shop sign was replaced by one for Beverly's Grill. Beneath it, a second sign read "Chicken in the Rough." Anyone who ordered it got a basket emblazoned with a cigar-smoking rooster filled with a half chicken, batter-fried, served

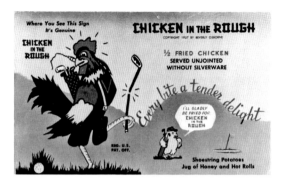

Chicken in the Rough was once served across the country in more than three hundred locations. *Courtesy Kyle Anderson.*

over shoestring potatoes with a biscuit and honey. Customers also received a little yellow tin bucket stamped with the logo partially filled with water to clean their fingers. The serving cost fifty cents.

A fellow Marlow native named Randy Shaw bore witness to the phenomenon from the ground floor.

"Beverly leased the grill and sold the service napkins to franchise holders," Shaw said. "He charged them two cents an order or two percent of the gross based on sales tax."[9]

Osborne worked with a local fabricator to develop a Chicken-in-the-Rough grill, four feet long and twenty-four inches wide with a fold-over top. With a trademark and copyrights in order and the grill patented, Osborne was open for franchising—one of the country's first.

Shaw came to Oklahoma City in 1937 looking for a summer job. He spent his first summer as a waiter. Before too long, Osborne made him manager of Beverly's Grill, which he continued until leaving to serve in World War II. By the time he returned, Beverly Osborne had helped change the course of restaurant history nationwide.

Chapter 3
IT'S THE SAUCE!

Dolores Restaurant had great hamburgers but the best was the apple pie and the Dolores Special: angel food cake with ice cream and lots of hot fudge poured over it.
—Dolly Foster, 1999

Ralph A. Stephens and his wife, Amanda, and toddler son, Robert, arrived from Ohio by way of Illinois in 1917. Ralph was assistant manager of the Western Hotel on Main Street; Amanda gave birth to her second son, Vincent, in January. With two mouths to feed, Ralph decided to go into business for himself, opening the Car Barn Café at 416 North Olie in 1921. Amanda gave birth to a daughter, Dolores, that December.

The Car Barn closed in 1923, but Stephens rebounded by partnering with E.V. Bodkin to open the Puritan Café at 102 North Broadway. When the Puritan partnership busted a few months later, Ralph and Amanda remodeled the space and reopened in September as Stephen's Restaurant. The menu in the new place included Amanda's butterscotch, banana and cherry pies, foreshadowing secret to future success. But fate wasn't ready to smile on the Stephens family. Ralph was thirty years old and had a pile of debt and three failed restaurants to show for his efforts. So he and Amanda packed up the kids and moved to Dallas.

Once there, Stephens passed a Pig Stand crowded with cars and reckoned it would be a good place to make an honest wage while learning to run a successful restaurant. So he found work at one of the growing number of local Pig Stands, where he did well enough to earn the chance to open one

in Little Rock, Arkansas. The Stephenses packed and headed east, but not before swinging through Hannibal, Missouri, for a family visit. Amanda's father, Jesse Ogle, was a well-known carpenter but knew a good deal when he saw it and agreed to partner with Ralph on a place of their own. In June 1925, Goody-Goody Barbeque opened for business to initial success that waned once winter arrived. Looking for warmer environs, the Stephenses moved to Tampa, Florida, which was in the midst of a real estate boom. Goody-Goody was an enduring success there, but the Stephenses sold it in 1929 and moved back to Oklahoma City.

Once back home, Ralph and Amanda had enough cash to get established, and Oklahoma City's economy had not yet felt the Great Depression. Despite finding pockets of success with barbecue and sandwiches, the Stephenses were in desperate need of a comeback. The good news was they had one packed in their luggage.

While in Hannibal, Amanda learned a recipe for a special sauce from a barbecue stand in nearby Quincy, Illinois. They used it at the Goody-Goody, and it quickly built a reputation with customers. The sauce had a tendency to bring customers back for more, so they called it Comeback Sauce. With the recipe in hand and some cash to invest, the Stephens family opened the Dolores Restaurant, named for their daughter, at 33 Northeast Twenty-third Street in 1930. The first year, Stephens reported $52,000 in gross sales.

"We never closed our doors when The Depression hit, but we were selling hamburgers and malts for a dime each to stay open," Stephens said.[10]

In 1932, the Dolores advertised "drastically reduced prices," including, for a dime, sandwiches (hamburger, cube steak, barbecue pork, beef and ham, bacon and tomato, hot chicken salad, pork tenderloin) and pie (made under the supervision of Amanda and including butterscotch, coconut cream, lemon, chocolate, apple and banana). Chili and chicken noodle soup cost fifteen cents. Su-Z-Q potatoes hit the menu in 1938.

Stephens built parking stalls behind the restaurant to offer drive-in service for the many vehicles passing along nearby Route 66. By the 1940s, Dolores was becoming a top pick for Route 66 guidebooks. Duncan Hines recommended the restaurant in his 1941 book *Adventures in Good Cooking*, saying, "I enjoy eating here, especially their steaks and Su-Z-Q potatoes and barbequed ribs. They have the best biscuits I have found anywhere in America, made by Neal, a colored woman, who does not use a recipe, but has a remarkable sense of feel, which tells her when the mixture is right—served twice a week (I suggest you wire ahead requesting these remarkable biscuits). Their menu provides a variety of good salads and other things, and I hope

Interior views of the Dolores Restaurant. *Photos courtesy Kyle Anderson.*

you are fortunate enough to find Mr. and Mrs. Ralph Stephens there, so you may meet them personally."

In 1944, Ralph and Amanda Stephens moved to California. They opened a Dolores Drive-In on the Sunset Strip in Hollywood and followed up by opening three more restaurants. They left the expanded dining room of the original in Oklahoma City and put Amanda's brother Bob Ogle in charge of management. Oldest son Bob Stephens followed his parents to California in 1956 and took over operations there in 1961 when Ralph moved back to Oklahoma City.

Amanda Stephens died in 1966. Two years later, a newlywed Ralph bought the Pub on North Western and then sold the Dolores to a group of investors, who kept it open until late 1974. Ralph still owned the property and silently watched its contents auctioned off in February 1975. The Dolores name endured in Los Angeles. The last of the remaining Dolores Restaurants in West Los Angeles was sold in 2008. The restaurant burned down on Christmas Day 2012.

Chapter 4
SPECIALTY DINING

Today, Oklahoma City boasts myriad specialty restaurants serving menus founded on ethnic culture or style of cuisine. Seafood was the first specialty cuisine commonly served at local restaurants, with barbecue and the exotic flavors of the Far East and south of the border not far behind.

BARBECUE

In pre-statehood Oklahoma, barbecue was most often the stuff of cookouts and a takeout favorite from butchers and grocers like Kamp Brothers Market, which opened in 1910, and the J.L. Wyatt Grocery, which opened shortly after the land run. Wyatt's evolved into the Crescent Market and stayed in business for 122 years. Different members of the Kamp family operate Bill Kamp's Meat Market and Kamp's 1910 Café today.

It wasn't uncommon to find those who sold barbecue from a home or a stand, but restaurants selling barbecue day to day were scarce. Even Pete's Barbecue, one of the city's first, sold spaghetti and other items along with barbecue via cafeteria line. Pete Paschal came to the United States from Greece in 1912 and Oklahoma City in 1916. He opened his place in 1920 at the corner of Exchange and Western Avenues. Paschal would

quietly raise a family on "fine barbecued meats, steaks and chops" for forty-two years. The World War I veteran was a popular member of the St. George Greek Orthodox Church, and he and his wife were longtime contributors to the church's annual food festival, which continues today.

MARSH'S PIG STAND

Max Baer, the heavyweight boxing champion, and his manager came by one afternoon. They ordered Cokes and ice for a mixed drink. When they left, there was a whole quarter on the tray, my biggest tip of the summer.
—Gerald Durbin, 1935

Pete Paschal wouldn't have much stiff competition until shortly after the massive Inauguration Barbecue and Square Dance for newly elected governor J.C. Walton in 1923. That was when Hubert Marsh bought the rights to the "Juicy Pig Sandwich" that had become all the rage in Dallas, as Ralph Stephens found out. Marsh, who also sold a line of orange juice, used those exclusive rights to open the state's first Pig Stand in the spring of 1924 at 511 East Twenty-third Street (now Northeast Twenty-third Street) across the street from the Capitol—only five months after Walton was cast from office.

Marsh's daughter Mary wrote to the *Daily Oklahoman* in 1991: "At the opening of the first drive-in located across the street from the state Capitol, policemen had to direct traffic caused by the novelty of the first drive-in in Oklahoma City. I believe it was the first drive-in in the state."

By summer, a second Pig Stand had opened in Capitol Hill, on the city's south side. A third opened at North Western Avenue and Northwest Twenty-third Street by 1927, each with a "drive-by" open "day and night." In 1929, a fourth store opened in Norman on Campus Corner, and a fifth opened at Eighteenth and Broadway in 1930, adjoining the Colonial Bakery Plant. Nos. 1 and 5 were open all night; 2, 3 and 4 closed at 2:00 a.m.

Proximity to Colonial Baking turned into a boon when Marsh commissioned it to customize buns on his stores' behalf. The bun was cut in half and the knife stuck into it, making way for a special electric wedge iron to simultaneously hold and toast the bun. A specially designed trough and a scoop filled the toasted bun with the patented pork recipe.

Long before Dub Adams became a successful caterer and owner of Dub Adams Hickory Kitchen, he managed the Marsh's Pig Stand on Northwest Eighteenth and Broadway in the 1940s and '50s. He wrote in to Melba Lovelace, columnist for the *Oklahoman*, to explain that there was no recipe for the Juicy Pig Sandwich, nor was there a sauce. Adams said they bought fresh bone-in pork hams and rolled them in crushed black pepper and salt, then slow-roasted them in the barbecue pit until the following morning. Cooked hams were then removed and boned. Bones and skin were added to an already simmering stock along with a handful of whole cloves and bay leaves. The cooked pork was thinly sliced, layered in a pan, covered in stock and held at low temperature. The final sandwich was a toasted bun stuffed with juicy pork, drizzled with stock and topped with sour pickle relish, which was made by the Gandy Pickle Company and arrived in fifty-gallon wooden barrels that were never refrigerated.

"So you see," Adams wrote, "it was more of a process than a recipe."

Marsh's Pig Stands closed one by one, and the location at Northwest Eighteenth and Broadway evolved into Marsh's Drive-In, which became a popular haunt for teens through the 1950s and into the early 1960s.

Today, Shawnee's eight-decades-old Van's Pig Stand has a presence in Oklahoma City and Norman, but the only place to get the Pig Stand experience today is at Bob's Pig Shop in Pauls Valley, which was opened in 1933 by Bob and Helen Hammons.

Bob and Helen went to see Marsh, who became their friend and mentor, sold them their equipment and taught them what he knew. The Hammonses retired in 1976, selling Bob's to Phil Henderson. Bob taught Phil the sandwich "over a period of about a month."

"It does, indeed, have a sauce with a specific recipe," Henderson wrote in a letter to the *Oklahoman* in 1991. "Bob admonished me to never write this secret recipe down, and it could not be duplicated without my permission."

Henderson still operates today. He concluded his letter in 1991 this way: "Since I took over in '76, I have been steeped in the stories and secrets of the Pig Shop. I view my position in this little place as custodian of a sacred trust, as much as I am manager, cook, cashier, maintenance man, etc. I occasionally deliver prepared 'pig,' complete with the sauce to some of the old friends of Marsh's Pig Stand."

Hans

Hans Abrahamsen left Andebu, Norway, in the mid-1920s to join his brother in New York. When Abrahamsen arrived to port, he was devastated to learn his brother had died. Desperate for work, young Hans migrated west, where he found work in Oklahoma wheat fields during harvest and stayed on in Oklahoma City.

He opened a restaurant in 1929 near the interurban turnaround at Northeast Ninth and Eastern. Legend has it that Hans met his future wife, Dorothy, in the restaurant and married her in 1939 between lunch and dinner.

During the Depression, the restaurant served sandwiches made with lettuce, bread and butter for a nickel. Barbecue sandwiches went for fifteen cents. The restaurant survived the Depression and World War II, eventually finding enough prosperity to endure for six decades through several moves, finally reaching 4101 Northwest Tenth in 1964, where it remained open until October 1990.

Hans was famous for meats slow-roasted in an open wood pit and served with house-made sauces. It was close enough to the Springlake amusement park to draw celebrities who performed there, including Roy Rogers, Dale Robertson, Anita Bryant and Patti Page.

In 1976, Hans turned the business over to his daughter Karen Haley, who was in charge when the restaurant earned a blue-ribbon endorsement from *U.S. News and World Report* in 1986.

"It's been a great 62 years, but it's just time to retire the place," Haley said of her decision to close.[11]

HERMAN'S SEAFOOD

Delmonico Restaurant, which was at 11 North Broadway Avenue, began advertising "Fresh Baltimore Oysters…served in any style that you wish" in the *Daily Oklahoman* in September 1901. The announcement claimed that Delmonico was prepared to furnish the public with fresh oysters—New York Counts and Extra Select—every day in the season, served any style the customer wished. Delmonico guaranteed satisfaction in service and "respectfully solicit[ed] your patronage."

Seafood was a common go-to for restaurants looking for an edge. But the city's first major seafood restaurant was opened by a World War I veteran named Herman Baggett, who returned from the war with a trade. He and his wife, Mary May, nicknamed Tiny for her four-foot-ten stature, packed their belongings and migrated north to Oklahoma City in 1925. He had no trouble finding work, thanks to his experience as an army cook. Baggett toiled for ten years in other people's restaurants, most notably as manager of Bishop's, until he saved enough money to open his own place—a sandwich counter at Northwest Fourth and Hudson. In 1939, Baggett changed the counter into Herman's Restaurant, "specializing in seafood!"

"Daddy was bringing in fresh seafood when that sort of thing was unheard of," said his late daughter Susie Gray in a 2010 interview with the *Oklahoman*. "It came packed in ice every day."

Pompano, swordfish, soft-shell crab and lobster were shipped in daily; the crustaceans were shipped in barrels packed with seaweed, according to Baggett's grandson Ken Gray.

"People lined up out the door and into the market to get in," Susie Gray remembered.

She said the market was a common stop for housewives. "Women didn't like to touch the raw fish so much, so Arnold [James] would fillet and clean the fish for them," she said. "Then he would bread it with our seasonings, wrap it up and tell them how to cook it once they got home."

Baggett moved his restaurant to Northwest Sixteenth and Classen under an outlandish neon sign adorned with a swordfish. Herman's would sustain the Baggetts until 1969, when it was sold to Val Gene and Associates, who operated it under the Herman's name through the 1970s. "Those were some of my favorite memories," said Maggie Vallion, who left nursing to operate Herman's for her brother Jim and his partner Gene Smelser.

Herman Baggett died less than a year after selling. Tiny died in 1980. In 1991, Susie and Ken Gray reopened Herman's on Northwest Expressway for a couple of years. Ken Gray still mixes the coleslaw for a select clientele. "I've tried having it mass-produced, but no one can seem to get it just right," he said. "There's some places that claim to make Herman's Cole Slaw, but I'm the only one that has the true recipe."

TEX-MEX AND CHINESE FOOD

Mexican food was probably the first ethnic food sold in the Oklahoma City area, as chili and tamale wagoneers wandered north from Texas. But the Chinese were the first to open free-standing restaurants.

A few hundred Chinese laborers, recently displaced upon completion of America's first transcontinental railroad, found their way to Oklahoma about the time of the Land Run.

Laundries and cafés were common means of income in the early days. Chinese immigrants were treated poorly, as illustrated when Congress approved 1882's Chinese Exclusion Act, banning future immigration. Chinese immigrants were forced to live a life apart and to build closed, often hidden, communities.

Mixed in with abstractors, detectives and other early twentieth-century entrepreneurs advertising their services in the *Oklahoman*'s 1909 Ready Reference Directory is a heading for Chinese cafés. Places like Wing Shing at 18 South Robinson sold coffee with cream, regular meals and chop suey for a quarter. Short orders were offered day and night.

The Imperial Café served "the finest Turkey Dinner in the city…served Table d'Hote for only fifty cents from 3:00 to 8:00 p.m.," along with short orders and chop suey "serv[ed] in American and Mandarinic style" in 1913.

Sam Choi, owner of the Kingman Café, was the most successful Chinese restaurateur of his time. As a boy, Choi was called Sheung Wah. When he married, he was given a man's name, Ng Duck Foon. He used Sam Choi as his business name and Ben Wong to show his relationship to Emperor Wu of the Chou Dynasty. Later in life, he used Eng as his American surname, as did his descendants.

A headline in the January 10, 1918 edition of the *Oklahoman* proclaims, "Sam Choi Will Go 10,000 Miles for His Chinese Bride."

> *Lonesome Sammy travels over the streets of this jewel city of the southwest and listens self-consciously to the harsh honk of the auto horn and the roar and clankety-clank of the Katy flier but…*
>
> *All this time his thoughts are of a far-off land where "th' temple bells are callin' and a little almond-eyed maid with scented hair and cherry blossoms at her slim waist and an ache in her heart is 'just a-wearyin' for him."*

Choi, described by the paper as a six-year resident at the time, had the day before set about to obtain a passport to travel home to marry "the little

girl in old Hong Kong." With a letter of recommendation from LeRoy M. Gibbs, secretary of the chamber of commerce, he received the passport to fetch his bride.

But when it was detected that Choi's paperwork included a "clever forgery," he was held for questioning. When the debacle became public knowledge, Choi left for good. Arriving in Hong Kong with $30,000, he built an expansive two-story Chinese-Western-style house that family called the Red Mansion, thanks to its red-brick exterior. During China's civil war, a cannonball destroyed the roof, and Choi returned to the United States, where he settled in Seattle and started his family.

Roger Eng would say in 1984 that his father left Oklahoma City about 1920 to wed his mother.[12] Together, they would raise eleven children in Seattle. The youngest child, Roger visited Oklahoma City in an attempt to account for about twenty years of missing family history. Eng, a chemist turned dentist who was elected the first Chinese American mayor of Los Altos, California, in 1980, said his father continued to own a part of the Kingman Café until it closed in 1945, replaced by Hall's Clothing.

The China Street Underground

Shortly after Choi left, Oklahoma City was hit by a deadly flu epidemic. The Chinese went into the shadows, gathering in hastily constructed catacombs lit by lanterns and candles and known at the time as "China Street." It was centered at the intersection of Robinson and Grand Avenues. New immigrants found food, shelter and opportunity from fellow countrymen. Local Anglos found exotic flavors and a new avenue for vice.

Over the next two decades, the Chinese filled all available space in Chinese-owned homes and businesses, sending later-arriving immigrants into basements and subbasements of the same buildings. As arrivals increased, basements were divided into numerous rooms, sometimes connecting doorways and very short passages between adjacent basements, like a subterranean hamster cage for humans.

The China Street underground continued until 1943, when the Exclusion Act was repealed. Witnesses say the subterranean community vanished completely by 1948. It would be rediscovered in 1969 when the property was dug up to construct the Myriad Convention and Civic Center.

TEX-MEX ARRIVES

Tex-Mex cuisine had evolved from when the dried chiles of Tejas clashed with southern-style gravy. Chili gravy became all the rage, first smothering tamales and then enchiladas. When those transient operations thinned, a few stayed behind. In December 1932, Joe Ontiveros advertised in the *Oklahoman*: "Genuine Mexican Tamales at Café, 15 cents a dozen—Wagons 20 cents a dozen. Special every Saturday and Sunday Enchalades Chicken Tacos, 211 West Choctaw (South 7ᵗʰ)." Unbeknownst to Ontiveros, he was laying the groundwork for young Luis Alvarado.

Growing up in Mexico, Alvarado learned to make tortillas the hard way: a ball of tortilla dough placed between two boards and pressed to form the familiar patty. Alvarado made tortillas in that manner for honest wages for five years before crossing the Red River and finding work in San Antonio. It was in the Alamo City that he was recruited to take a job in Dallas at El Fenix, which opened in 1918. He trained the staff how to use new-fangled tortilla machines, learning the restaurant business while he was at it. Then he spent three years working at a corn chip factory in New York, which he told the *Oklahoman* in 1951 was where he learned the most.

When he married Mary Cuellar, Luis operated a Mexican restaurant with his brothers-in-law Gilbert and Willie Jack Cuellar in Tyler, Texas. A few years later, Alvarado would choose Oklahoma City over Memphis, Little Rock, Tulsa and Muskogee for a place he and Maria could open on their own. El Charro opened on Northwest Tenth and Dewey in 1937. It would barely survive World War II but go on to inspire one of the country's most successful Mexican food chains and build a local legacy that has its fingerprints on practically every purveyor of Latin cuisine that followed.

Chapter 5
FROM DUBIOUS BEGINNINGS

Known today as Cattlemen's Steakhouse, current ownership dates the restaurant's birth (as Cattlemen's Café) to 1910, which is the year the building it occupies was built. But what's important about Cattlemen's today has little to do with the accuracy of its birth date. As for Cattlemen's history, what happened between statehood and World War II isn't as important as what happened shortly after the signing of the armistice and in the early 1980s. Relevant to the earliest days of Cattlemen's is where it opened and continues to operate today: Stockyards City.

Before it became known as the Oklahoma National Stockyards, the facility was called Packingtown. Just west of the city limits, Packingtown was the name given to the district where the cattle trade commenced. Railroad access made it a mecca for cattle ranchers, which made it a logical setting for meatpacking houses. The workforce engaged in thankless, grueling employment over long hours, drawing the attention of vice peddlers. Prostitutes, gamblers and bootleggers were outnumbered only by heads of cattle.

In 1910, a two-story brick building was erected on the 1300 block of Agnew Avenue. The Stock Yards Bank was the first to open in the new building. Bob Empie, former Oklahoma bank commissioner, described life in Packingtown for the *Oklahoman* in 1985. He remembered that Cattlemen's Café was the last restaurant in the area to eventually serve booze. "It was strange, because it was the hangout for bootleggers and gamblers while being the driest cafe in town," he said.[13]

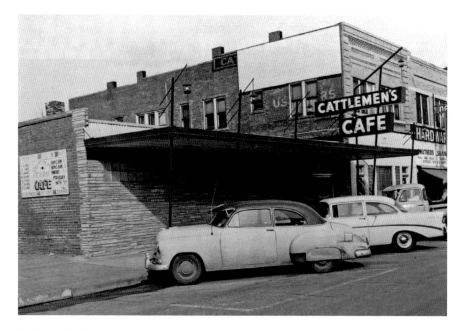

Cattlemen's Café, now Steakhouse, is the longest-operating restaurant in Oklahoma City. *Photo courtesy Cattlemen's Steakhouse.*

The owner was a friend of the gamblers and bootleggers, he recalled. The restaurant was open twenty-four hours a day, seven days a week. "It was good for us at the bank," Empie said. "We would get advance warning if bank robbers were headed toward Oklahoma City. The police would come and would occupy rooms over the bank and in the nearby drugstore. There never was a robbery."

The bank remained at the northwest corner of Agnew and Exchange from 1910 to 1969, when United Oklahoma opened new quarters. The Stock Yards Bank Building successfully drew a steady stream of businesses by 1920; some lasted, some didn't. The building housed a post office and places of business. W.L. Pierce operated a restaurant at 1311 South Agnew, sharing the space with grocer M.P. Wiseman in 1921, taking over from the Butcher Workmans Union, operated by R.J. Bates for several preceding years. That same space was home to the American Café in 1924.

The American Lunch Room was an expansion of the popular American Café, founded in 1904 by Lawrence and Florence Davis, who sold the place to a pair of brothers named McDonald sometime before 1908. The McDonalds expanded operations outside of downtown Oklahoma City to the up-and-coming Packingtown district at 1309 South Agnew.

The expansion of the American lasted only a year, and then another downtown favorite, Van's Café, took the spot. When the 1927 city directory was published, a new occupant for 1311 South Agnew was listed: Cattlemen's Café. When Gene Wade celebrated his fortieth year as owner in 1986, it was reported that the restaurant was opened in October 1926 by C.V. Paul, who reportedly sold it to Hank Frey, a notorious gambler, game-holder and bootlegger.[14]

The Kentucky Club

Hank Frey would never have met the next owner of Cattlemen's Café without Oklahoma City's gambling fraternity, which included characters like Percy Wade Sr., who abandoned his young wife and family in Weleetka with a bankroll of $4,000; and Jack Ritter, who ran the Big Six billiard parlor, where he made book on horse-racing and baseball parlays. But no one could match Tony Marneres's Kentucky Club.

Long before the building at 1226 Northeast Sixty-third Street was home to Gabriella's Italian Grill and Pizzeria or the Oklahoma County Line, it was a playground for adults seeking to do what they shouldn't. Marneres came to Louisville, Kentucky, from Greece in 1914, spent twenty years there and then moved to Oklahoma City. The Kentucky Club served steak and spirits with new-fangled air conditioning. Private dining rooms in the manner of horse stables, each with the nameplate of a Kentucky Derby winner nailed above it, surrounded the dance floor. High-stakes dice and card games were carried on in private rooms behind doors guarded by marshals in tuxedos. Trapdoors and a buzzer system offered a quick solution for police raids.

Eventually, the Kentucky Club moved to Western Avenue, near what would become the wealthiest portion of town, Nichols Hills, and brought its buzzer system and card and dice tables with it. Eventually, it became Bell's before a long run as Charlie Newton's, a favorite of former New York Yankees star and Oklahoma City native Bobby Murcer. The Deep Fork Group operated Charlie Newton's for a bit before the space was run by Johnnie's Charcoal Broiler owners David and Rick Haynes as Newton's. Hospitality veteran and local restaurant historian Kyle Anderson took the space and operated Kyle's 1024, featuring a menu celebrating Oklahoma City's restaurant history, from 2010 to 2015. The building was razed shortly after.

Part II
EVERYTHING GOES BOOM

The one-two punch of the Great Depression and World War II devastated local restaurants. Wartime conditions led Anna Maude Smith and a contingency of local operators to work with local officials to adjust to rationing policies. A weekly meatless day for restaurants swept across the nation and into Oklahoma City for a short time. In July 1945, Herman Baggett hung a "Gone Fishing" sign on the door of Herman's Seafood. The restaurant would remain closed until August 9. Fish wasn't rationed, but the only fish available in bulk during the war was the highest grade available, which Baggett couldn't sell at a profit. And despite the early success of El Charro, restrictions pushed Luis Alvarado to the brink.

"The war was on and we had to get stamps for our meat and stamps for our gasoline so we could go get the beans and rice," Alvarado said in 1968. "There was just my wife and myself and one or two helpers. I tried to sell the restaurant but nobody was interested."[15]

Many restaurants did close, but those able to survive were well rewarded in the postwar economy. That boom created opportunity for new places like Vic & Honey's at Northwest Seventeenth and Rockwell. Victor and Honey Boehnlein's private dinner club opened in 1946 and developed a loyal following before a fire spelled the beginning of the end. Despite a remodel, Vic & Honey's closed in 1960.

Pizza, extolled by servicemen who served in Italy, brought Italian restaurants to prominence. But the most significant postwar news in Oklahoma City restaurant history was made in a smoky room in the Biltmore Hotel over a roll of the dice.

HARD SIX TO EASY CHAIR

Whenever someone found out my father-in-law was Percy Wade, they always asked how they could get involved in his gambling. Of course, I knew very little because we didn't run in those circles.
—Norma Wade, 2012

On Christmas Eve 1945, fate placed bootlegger Hank Frey in Percy Wade Sr.'s regular dice game in the Biltmore Hotel. Down on his luck, Frey challenged young Gene Wade to a bet Wade should've turned down. Frey put up the most valuable thing he had left—a restaurant in Packingtown called Cattlemen's Café.

Wade Sr. came to town after leaving his wife, Hester, and four children, Lahoma, Gene, Kathleen and Percy Clyde Wade Jr., shortly after the youngest was born in December 1927.

"Percy left his wife nine months after Percy Jr. was born," Norma Wade, Percy Jr.'s wife of sixty-three years, said in a 2012 story. "Nobody out here in Weleetka even liked him. He was not a good man."[16]

"Oh, he was a stinker," Percy Wade Jr. said in the same interview.

Frey bet the younger Wade he couldn't roll a hard six, which is a pair of threes. Gene Wade was twenty-six, recently returned from a stint in the U.S. Army. He accepted the bet with his father's $25,000 pledge to back him.

Wade flung the ivories across the green felt table. When they came to rest, each showed a three.

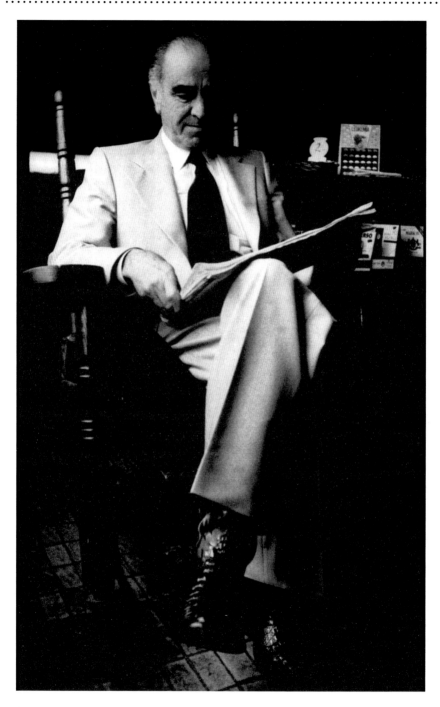

Gene Wade seated at the rocking chair where he spent most of his time in his later years. *Photo courtesy Oklahoma Historical Society.*

Over the following half decade, Percy Sr. would find himself in and out of court. He operated the Big House, one of the city's most notorious gambling halls. Luckily, Gene Wade turned out to be handy as a restaurateur, despite what his new neighbors thought. Forty years after he took it over, he would tell a reporter, "One said I'd last about three months, the other said six months."

His successor, Dick Stubbs, said Wade had a creative mind for business. Wade recalled taking over Cattlemen's on February 15, 1946, at a party thrown in honor of his forty years running it in 1986.

"We opened at 6 a.m. and that night we closed at midnight. I remember after closing, sitting there at the counter....I was the most frightened young man you ever saw," Wade said. "I was thinking to myself that I had a lot to learn."[17]

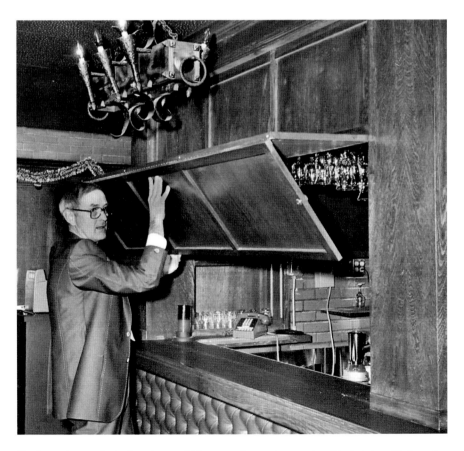

Cattlemen's once had a bar that could be stowed away to comply with state law. *Photo courtesy Oklahoma Historical Society.*

Gene's natural business acumen helped raise enough money to open Cattlemen's Drive-in on Exchange when the drive-in craze erupted. As Oklahoma City's cafeteria obsession blossomed, Wade opened Cattlemen's Cafeteria in Capitol Hill in 1965. When he recognized a loophole in Oklahoma's labyrinthine liquor laws, he installed a bar that could be pulled out of a wall. He also had a restaurant in Lawton.

Cattlemen's continued to operate around the clock, and crowds only grew over time.

"When we took over, the front door hadn't had a lock in it in something like 30 years," Stubbs said.

At some point, Gene Wade placed a rocking chair out by the entrance and would spend a great deal of the following five decades in it, greeting customers to Cattlemen's Café. Even after a young restaurateur took his own roll of the dice on Cattlemen's in 1982, Wade kept on rocking.

THE LEGEND OF SLEEPY HOLLOW

I had a beautiful dream that I went back to work and they served me lunch.
—*Edna York, age one hundred, 2006*

Eula Erixon, who'd served as Oklahoma's first female assistant attorney general starting in 1915, was as famous with friends for her fried chicken as she was for bond approvals. At their urging, Eula turned her hilltop home northeast of the Capitol into the Hilltop Supper Club. Years later, at the foot of the hill, she and her family would build the white-frame restaurant called Sleepy Hollow, where the pan-fried chicken she was famous for up the hill would buoy a fifty-year success story. But first the widow had to resign her post in the attorney general's office, which she did in November 1952.

After the house on the hill burned to the ground, Erixon moved to Northeast Forty-eighth and Lincoln Boulevard, where she continued to serve home-cooked meals to a growing group of friends. Eula and her son, Gustave, opened Sleepy Hollow at the foot of the hill in 1949.

"Mom Erixon came over here and saw a little hollow," said grandson Jim Erixon in an April 18, 1999 interview. "She said to my father, 'Junior, there's a creek down there and a little hollow. Let's call this Sleepy Hollow.'"[18]

The tiny home had just four tables and sixteen chairs. The original logo was an owl on a wooden sign that read "Sleepy Hollow Chicken and Steak Dinners." The family changed it to a depiction of the Headless Horseman from Washington Irving's legendary short story as the restaurant grew into a 270-seat restaurant serving up to nine hundred people on Saturdays.

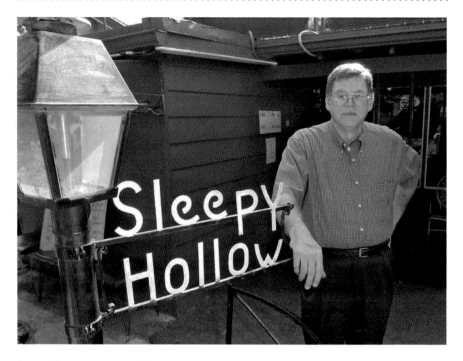

Bruce Kliewer purchased Sleepy Hollow in 1999 and operated it until 2005. *Photo courtesy Oklahoma Historical Society.*

Eula Erixon moved to Crested Butte, Colorado, in the mid-1950s and opened Erixon's Steakhouse. Gustave took charge of Sleepy Hollow and oversaw the restaurant's greatest climb, serving pan-fried chicken with biscuits, steaks, shrimp, mashed potatoes, gravy, peas, creamed corn and pineapple sherbet—all served family style. Its popularity led to locations in Tulsa and Fort Gibson Lake.

Jo Fleming spent thirty-eight years waiting tables at the restaurant.

"Everybody would start coming in at 4:30 p.m. and they'd be lined up in the lobby, the waiting room, outside the bathrooms, by the bar," Jo said in 1999. "The bar was wall-to-wall people. Everybody wanted to be seated in the main dining room to see who was coming in and what they had on."[19]

Melvin Boston was Sleepy Hollow's primary valet for nearly as long as Fleming worked the dining room. Mae Collins managed kitchen operations for more than a decade, building a reputation for the meatloaf she added to the menu. Donald Easley spent two decades frying chicken in cast-iron skillets and making biscuits as so many had before. Before Easley there was Edna York, who started in the early 1950s.

Chef Nordeen Bennai, who would spend nearly twenty years at Edmond's Cafe 501 and plenty more at Zorba's Mediterranean Restaurant, remembers frying chicken in shortening in those cast-iron skillets. Bennai said they put the uncooked pieces of breaded chicken and a huge scoop of shortening in a hot skillet and covered it with a heavy lid. A few minutes later, the lid would come off and the chicken would be crisping up in symphony with the simmering shortening.

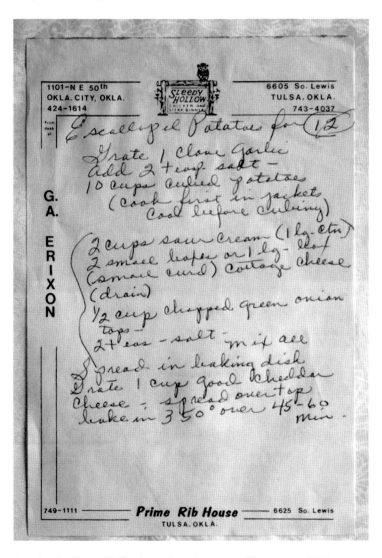

A recipe for Sleepy Hollow's escalloped potatoes. *Photo courtesy Oklahoma Historical Society.*

In 1993, the restaurant went into foreclosure. Pepperoni Grill pastry chef Steve Marks and Val Gene executive chef Houston Muzio purchased it. Marks took a buyout within a couple of years. Bankruptcy wasn't far behind for Muzio, who in 1998 was ordered to serve sixteen months in prison and pay $120,000 in restitution for bankruptcy fraud. Jim Smelser and Bruce Kliewer stepped up next.

"What I remember most about Sleepy Hollow is G.A. Erixon," Kliewer said shortly after buying the restaurant in 1999. "He was heavy set, and he always had his cigar. He loved that cigar!"[20]

But Sleepy Hollow's best days were long past. An armed robbery in 2002 ended with a bartender shot between the eyes and nearly killed. Kliewer closed in 2005. It was bought later that year by Otto McClinton and his daughter Yolanda. The restaurant didn't reopen until 2007, and McClinton died about a year later. Sleepy Hollow closed for good in 2008; only a concrete slab remains.

Chapter 8

THE CAFETERIA CAPITAL OF THE WORLD

As she approached middle age, Anna Maude Smith made a partner of her nephew Bob Smith, who put college on hold to serve as a B-29 bombardier in the air force during World War II. Bob rose to lieutenant before returning to civilian life, finishing up a degree in hotel and restaurant management at Oklahoma Agricultural and Mechanical College (now Oklahoma State University). Together, the Smiths were the guiding force behind a cafeteria craze that led to what the Oklahoma History Center's research showed was thirty-seven independent cafeterias that had a stranglehold on local diners for generations.

THE CLASSEN/O'MEALEY'S

O'Mealey's Cafeteria was really elegant for a cafeteria, with white cloths and napkins and even finger bowls with lemon slices floating in them! The apple dumplings were wonderful.
—Nina T. Davis, 1999

While Anna Maude Smith was still at the YWCA, Ralph Geist and his wife, Helena, owned and operated the Town Tavern in Norman. Geist was also an Oklahoma A&M graduate and friends with Bob Smith. Well aware of

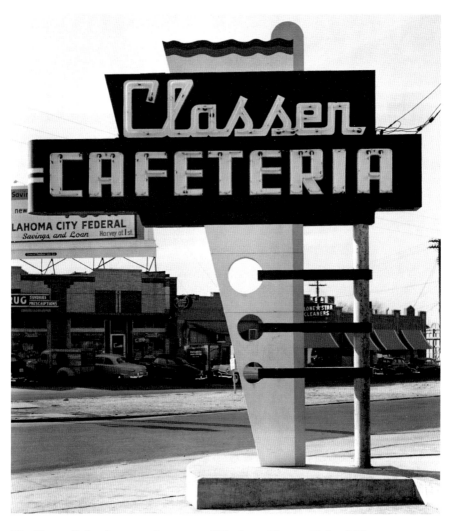

The Classen Cafeteria was on the corner of Northwest Twenty-third and Classen Boulevard. *Photo courtesy Oklahoma Historical Society.*

Geist's entrepreneurial spirit, Bob Smith convinced Geist that cafeterias were a worthy investment.

"He was always restless," his nephew Bill Geist recalled. "Always moving on to the next deal."

Geist found himself in the cafeteria business up in Enid, where he hired Naomi O'Mealey, whom he would lure to Oklahoma City after he opened the Classen Cafeteria in 1945. He and O'Mealey became fifty-fifty partners and opted to change the name to O'Mealey's.

Crowds lined up to dine at the Classen Cafeteria, which was briefly renamed O'Mealey's. *Photo courtesy Oklahoma Historical Society.*

The lines inside O'Mealey's Cafeteria typically stretched out the front door. *Photo courtesy Oklahoma Historical Society.*

"That had to be the greatest name in the world for a restaurant," Bill Geist recalled.

Ralph Geist and O'Mealey were the first to try a cafeteria outside of downtown, opening at the corner of Northwest Twenty-third and Classen.

Piano players or organists were common at Oklahoma City's classic cafeterias. *Photo courtesy Oklahoma Historical Society.*

A formal spread in one of O'Mealey's private banquet rooms. *Photo courtesy Oklahoma Historical Society.*

Lines outside O'Mealey's Cafeteria on Northwest Twenty-third Street often stretched past the Toddle House next door. *Photo courtesy Oklahoma Historical Society.*

Charles Dodson said in a 1999 interview that Geist and O'Mealey chose their location by counting the churches in the neighborhood and then staying open on Sundays. Alas, Ralph and Naomi did business differently, and after just a few months they went their separate ways. Naomi opened her first O'Mealey's Cafeteria twenty blocks east. Both places flourished.

Naomi and her son Harvey would eventually open four O'Mealey's Cafeterias over the next three decades and pay forward the generous spirit shown them by Anna Maude Smith. After O'Mealey's closed its last cafeteria in 1982, Harvey and his wife, Pat, opened O'Mealey's Pastry Shop and Desserts by O'Mealey. Naomi O'Mealey passed away in 1988, at the age of eighty-eight.

At the Classen, Geist brought in his cook from the Town Tavern, John Schroer Sr. The Classen remained open until 1967, by which time Ralph Geist had opened the Lady Classen Cafeteria in far north Oklahoma City.

ADAIR'S

Our family did not eat out often, but how we LOVED Adair's Tropical Cafeteria. It had a sinuous curvy sculpted ceiling that was dark green. But, best of all, along the line were tropical fish tanks. If you go there today to shop for antiques, the ceiling is still its green, curvy self.
—*Susan Gray, 2015*

Ralph Adair spent thirty years in office as an Oklahoma County commissioner when he wasn't running a restaurant of one kind or another. After college in Weatherford, Adair went west to Hollywood, seeking fame and fortune but finding little more than respite from a harsh Oklahoma winter, as he never rose above movie extra. Adair returned to Oklahoma City in 1930 and started an ice business on credit and built up enough money to purchase a defunct club in 1947 on Lincoln Boulevard, converting it into Adair's Cafeteria. The Tropical Cafeteria opened in 1951 at the corner of Northwest Twenty-third and May Avenue, where the 23rd Street Antique Mall operates today.

"We were an Adair's family," longtime Oklahoma City restaurateur Chris Lower said.

Adair's became well known for its chocolate icebox pie and pink-and-green dining room. The Uptown Cafeteria in Midwest City opened in 1956. The Camelot Cafeteria was opened in the 1970s near Will Rogers Park. Ultimately, Adair had a chain of fourteen cafeterias in Oklahoma City, Tulsa, Duncan and Norman. Ralph first ran for the county commissioner's seat for District 1 in 1953, won it and kept it for thirty years. Adair's was among the first to offer unlimited dining with its catchphrase "When you dine at Adair's you say 'when.'" Unlimited trips through the line cost $1.99.

Ralph's sons Gerald and Jim and grandson Glen all followed in his footsteps. After graduating from Northeast High School, Gerald joined the air force and learned finance before returning home to become president of Adair's Cafeteria's, Inc. Under his guidance, the family business operated seafood restaurants and purchased Bishop's Restaurant in 1967 in a show of support for the waning fortunes of downtown, but it closed two years later.[21]

Adair's, Inc. also bought Crosstimbers Restaurant on the south side of Norman and opened Mr. Bill's there.

DODSON'S

Of all the places in Oklahoma City, Dodson's was our choice—especially for the pies.
—Kyle Anderson, 2010

The Northeast Cafeteria opened at 1820 Northeast Twenty-third Street in 1952, the same year the first of three Dodson's Cafeterias opened in south Oklahoma City. Ruby Lee and Ben Dobson were successful operators from Cordell and good friends with Naomi O'Mealey. Under her mentorship, Ruby Lee and Ben helped their son Joe and his wife, Charlotte, open the first cafeteria in Capitol Hill.

"Mrs. O'Mealey was a gracious and wise mentor, and deserved credit for maintaining and advancing the standards for cafeterias and helping boost Oklahoma City's reputation as the Cafeteria Capital of the World," Charlotte Dodson said in a 2011 interview.

Charlotte said they were proud to be a part of an era of restaurateurs when they spent their days making sure food was up to snuff and the dining room was always immaculate for their diners, whom they considered family. They were so proud that, in 2010, Charlotte teamed with her son Charles, who worked many years in the family business, to write a book about their experience, *Life on the Line,* which includes family history and plenty of recipes.

"The food was so good in cafeterias in those days," Charlotte said in 2011. "We all were close-knit families. It was a glorious time. We all had such loyal customers."

An accomplished organist, Joe Dodson spent many of his evenings providing musical accompaniment in the dining room. A Dodson's was opened on Reding in 1956; it stayed open until 1992. The Hillcrest Dodson's Cafeteria was open from 1960 to 2000.

"We had the finest green beans in the city," Joe said in 2011. "We once had a little boy in for his birthday, and we were all set to bring him out a little slice of cake with candles, but he said he wanted green beans instead of cake. So, [we] packed the green beans together and carefully put some candles in them and brought it out."

After the final Dodson's closed, Joe Dodson played organ at a local Luby's. One evening he saw a father and son having dinner and asked the little boy how he liked his green beans. When the boy replied they were fine, Joe took the opportunity to plug the green beans he'd been so proud of, including the story about the boy who wanted green beans instead of cake.

Charlotte Dodson and her son Charles of Dodson's Cafeteria. Charlotte and her husband, Joe, operated three cafeterias between 1952 and 2000. *Photo courtesy Oklahoma Historical Society.*

"The father turned to me and said, 'I was that little boy,'" Joe said.

The man's name was Jerry Dicharry, and after Joe passed away in early 2015, Jerry had this to say in an exchange with me:

> *As a young kid, my family ate at Dodson's every week after church and on many other occasions. I always ordered three bowls of the green beans as*

my side dishes. The day they brought me the large dish of green beans with birthday candles showed what was so special about the Dodsons. They knew, and cared about, their customers.

We were still eating at their cafeteria until it closed; in fact, it was my daughter's favorite place to eat and where she wanted to go on her birthday. My son was only six when they closed the last store, so the encounter with Joe at Luby's was very memorable to him, but especially to me.

I feel sorry for all the people who will never get the chance to eat at Dodson's and experience that incredible hospitality and great food. If they were still open today, I would head there tonight and have my three bowls of green beans in Joe's honor.

THE LADY CLASSEN

My grandmother's favorite was Lady Classen. I loved their cranberry Jell-O salad. We ate there with grandparents, parents, siblings and children. After my mother died, two of my siblings met there every week to mourn and talk about how lucky we were to have her. After many weeks our tears turned to laughter, and we continued to meet there weekly until they closed.
—Dianne Bernstein, 2015

The Lady Classen Cafeteria opened under the guidance of Ralph Geist in 1953 at 6904 North May Avenue. Bob Smith bought it from Ralph and sold it back to him in short order. As much as Ralph enjoyed starting new ventures, he never had much patience for sticking with them too long. So, Ralph recruited his nephew Bill to move to Oklahoma City to work at the Lady Classen.

"My uncle was sitting at the desk, and someone was talking to him," Geist said in 1989. "I said 'Where do I sit?' He looked up at me and said, 'You don't. I want you out there, with the customers.'"[22]

And that's where Bill Geist and his wife, Shirley, stayed until 1994, first as a manager under his uncle and then as cafeteria owner with his sons John and Jim working with him.

Recipes at the Lady Classen in 1994 were the same as when the place opened in '54. Employees rarely changed, and customers' demands rarely extended beyond the lamb, chicken-fried steak, beef tips and Austrian ravioli.

Fresh flowers on the tables and oil paintings on the walls were a signature, and the decor was accented by early American engravings, brass chandeliers,

a cherry cupboard and a mahogany china cabinet. Silver flatware was washed twice. Each roll of silverware in white cotton cloth napkins cost the Geists a dime per use. Silver sugar holders, water pitcher tops and salt-and-pepper shaker heads were shined weekly.

All told, head pastry cook Maggie Brown, meat man John Fields, salad matron Winnie Nunnally and head porter Cleo Bryant worked at the Lady Classen more than 125 years. Geist closed the cafeteria for two weeks each Christmastime, a move appreciated much more by the staff than his customers. Longtime patron Larell Olson wrote in 1994 about standing in line behind a senior gentleman who, as he was picking a salad, told the lady serving him, "I'm so glad you're open again. I'm sick and tired of eating out!"[23]

Asked if he considered Lady Classen the "silk stocking" cafeteria in the cafeteria capital of the country, Bill Geist didn't hesitate: "That would be fair, yes."[24]

THE QUEEN ANN

The cafeteria itself is really a tribute to a real queen, Anna Maude Smith.
—*Bob Smith, owner, 1965*

Not too long after partnering with Cooper Lyon to take over his aunt's Anna Maude Cafeteria, Bob Smith sold his interest to Lyon and built his own place on the ground floor of United Founders Tower, a gleaming, modern building near Lake Hefner, topped by the swank Chandelle Club.

The modern, 10,600-square-foot concept was decorated in Queen Anne style, of course, with furniture pewter pots, mirrors and pictures from England to highlight the décor of the establishment, opened in 1965. At the time, it seated 290 persons at sixty-six tables. The buffet was made of rosewood and designed and constructed to give the appearance of an English harvest table, departing from the usual stainless steel. After nineteen years in the cafeteria business, Smith not only knew how to successfully run one, he had a throng of loyal customers that helped make the Queen Ann an instant success.

Smith spent the next seven years building the Queen Ann into a modern interpretation of the Anna Maude, rotating European furniture in and out of the lobby along with the artwork and a succession of conversation pieces like a sixteenth-century porcelain stove from Switzerland.

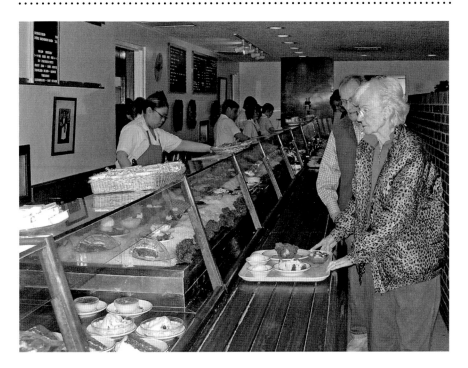

Trays slide along a wooden line at the Queen Ann Cafeteria. *Photo courtesy the* Oklahoman.

In the kitchen, Smith followed his aunt's blueprint of fresh bread made daily and house-made pastries. In addition to classic, wholesome entrees, Smith offered a variety of salads and vegetables, including peeled tomatoes with cottage cheese, deviled eggs topped with stuffed olives and fried chicken every Sunday.

Ever the restless spirit, Smith sold the Queen Ann in 1972 to young John Schroer Jr., who was a partner with his parents and brother Robert at the Boulevard Cafeteria. Four years later, Schroer opened a second Queen Ann in Midtown after his family moved Boulevard Cafeteria from the building it had occupied since 1948. The second Queen Ann operated until 1982.

The original continued under Schroer until it was forced out of its lease in 2006. When Schroer closed, Bob Smith's widow, Jane, visited to offer her well wishes.

More than fourteen hundred people went through the lunch line on the Queen Ann's last full day of operations in 2006.

"It's the closing of the Queen," Joe Nelson, who traveled with his wife from Stillwater, said. "It's really so sad."[25]

THE BOULEVARD

The Boulevard has been a favorite meeting place for my husband and me, my husband and his friends, my siblings and me, and in fact it is the last place my brother and I shared a meal right after he was diagnosed with leukemia. We loved their fish, cornbread, pea salad and pies. We also really enjoyed seeing all the pictures of old Oklahoma City that were on the walls.
We have been "cafeteria people" for as long as I can remember. We have eaten many delicious meals in them, celebrated happy events, mourned sad events, discussed current events and personal sagas, we have laughed and cried all along the way and have missed each and every cafeteria as they have closed one by one.
—Dianne Fernstein, 2015

Of the thirty-seven cafeterias in Oklahoma City, Boulevard Cafeteria in Midtown operated deepest into the twenty-first century. When Garland Arrington put his Boulevard Cafeteria up for sale in 1956—eight years after opening—John Schroer Sr. partnered with Nu-Way Cleaners founder Pat Denham to buy it. Schroer's career in the food business had taken him from the Hudson Hotel coffee shop to Geist's Town Tavern before he found his way into the cafeteria business.

Schroer lost his partner in 1960. When liquor finally became legal to sell in 1959, Denham was positioned to quickly become the state's top liquor retailer. According to Byron's Liquor Warehouse, Byron Gambulos said Denham kept low prices despite "interests in New York" demanding he raise prices.[26] In August 1960, Denham was killed after his boat exploded when he attempted to start it.[27]

Schroer brought sons Robert and John Jr. into the business. But when Bob Smith was ready to sell his Queen Ann Cafeteria in 1972, John Jr. purchased it on his own.

Then things went awry for the Schroers. A 1976 blurb in the *Daily Oklahoman* announced that a second Queen Ann would replace the Boulevard, which was moving elsewhere. John Jr. filed an injunction to stop the move, claiming he was 50 percent owner of the Boulevard and "decisions affecting the business were being made without authority and without his consent." His parents contended they were moving because John Jr., who was owner of the building, had raised the rent by 300 percent.[28] The judge allowed John Sr. to move the business, which was on the north side of the Plaza Court, literally looming over the second Queen Ann, which lasted about six years.

Youngest son Bill joined the Boulevard in 1978, and John Sr. and Florene retired in 1979. Bill and his wife, Malin, opened Hudson's restaurant in Edmond in 1984, in honor of his father's first restaurant in the Hudson Hotel.

Just before Christmas in 1989, Robert had a massive heart attack in the kitchen and died. He was forty. Bill purchased the business, but not the property, from his brother's estate. Bill passed away in 1998, leaving the Boulevard to Malin, who brought sons Harrison and Stewart into the business when they were old enough. The Boulevard continued to operate until December 11, 2015, ending a ninety-seven-year era.

The Lunch Box

We call this the Poor Boys Petroleum Club.
—Mickey Homsey, 2001

John B. Papahronis, an immigrant from Vlaherna, Greece, opened the Lunch Box (originally the Lunch Bar) in 1948. He saved money from shoe-shining and an ice cream cart and partnered with his son Aristotle

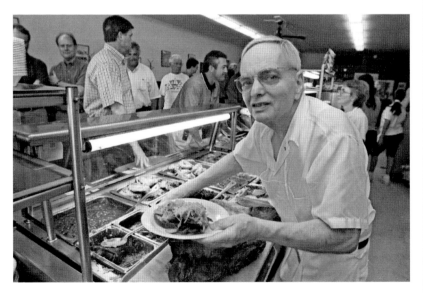

Johnny Papahronis took over the Lunch Box from his father, who opened the downtown cafeteria in 1948. *Photo courtesy the* Oklahoman.

"Johnny" Papahronis to open on Grand Avenue (now Sheridan). For decades, its serving line was famous for corned beef, meatloaf, barbecue, pot roast, spaghetti and meatballs, hot beef sandwiches smothered in gravy, Reuben sandwiches, burgers, franks, mashed potatoes, macaroni and cheese, fresh vegetables and fruit and homemade bread and pies.

For years, the café was open on Saturdays and served breakfast and dinner. The restaurant doubled its size in 1981. After over a half century of service, in 2001, Johnny Papahronis's failing health led him to sell to Ed Strawn, a loyal patron with thirty years of restaurant experience at the Beacon Club, the Petroleum Club, Pistachio's and Michael's Plum. The Lunch Box closed for good in 2013.

9
OUTRANKING THE COLONEL

When Randy Shaw returned from World War II, Beverly Osborne's franchising strategy was an unmitigated success. A team of traveling salesmen whom Osborne hired helped land Chicken in the Rough in cafés, drugstores, truck stops and various other operations across the country and abroad. Business was so good that Osborne recruited his fellow Marlow man to skip college.

"I was 20 years old when he made me the manager," Shaw said. "At that time, Beverly said I was making more than some college professors, so why go to college?"

The success of franchising allowed Osborne to expand existing properties and open new ones. In 1941, Osborne had Beverly's Drive-In, Beverly's Gridiron (now 1492 Latin Grill), Beverly's Grill, Beverly's Lawton and, later, Beverly's Hideaway for high-rollers at Northeast Fifty-second and Santa Fe. When World War II rationing threatened his supply, Osborne began raising chickens for eggs and pigs for ham and bacon on his home property.

Chicken in the Rough was making nearly $2 million a year by the end of the 1940s, sold in about 350 franchise outlets as far away as Johannesburg, South Africa. By 1950, licensed sellers of Chicken in the Rough had sold about 335 million orders, landing a story about the Osbornes in *Time* magazine that year.

Harland Sanders of North Corbin, Kentucky, might've read that story, because five years later he sold his Sanders Court & Café stores and went on a similar franchising campaign with his fried chicken recipe.

BEVERLY'S GRIDIRON — 1207 N. Walker

Above: Randy Shaw worked for Beverly Osborne as a young man and eventually became the owner after his mentor's death. *Photo courtesy Oklahoma Historical Society.*

Left: Beverly's Gridiron was located in what is now the heart of Midtown. *Courtesy Beverly's Pancake Corner.*

A satisfied franchisee in Utah eventually marketed it as Kentucky Fried Chicken.

Osborne made Shaw his partner in 1954, about the time Beverly's Drive-In became the landing point for a good portion of the teen population on

Saturday nights. Not only did kids come for Chicken in the Rough, they also filled the restaurant north of the state Capitol for Six-by-Six Smokerburgers.

"R.G. Miller, who used to write the Smoking Room column in the *Oklahoma City Times*, wondered once why no one made a big hamburger," Shaw told *Daily Oklahoman* columnist Max Nichols for his May 30, 1982 column. "So we came up with a hamburger with six ounces of meat and a bun six inches in diameter, and called it Six-by-Six."

It would later become known as the Big Bev Burger, which it still goes by today. Osborne built the nine-stool drive-in he opened in 1937 into a twelve-hundred-seat restaurant and drive-in in the 1950s, gearing it toward teenagers, who often got carried away.

"I remember when [former governor] David Hall was a teen-ager and I caught him emptying the paper towels out onto the restroom floor. I made him clean up the towels and mop the floor," Shaw said.

Business was good enough to build Beverly's Pancake Alley at Northwest Sixteenth and May Avenue in 1954. Two years later, Osborne partnered with sporting goods magnate Andy Anderson to build a property that included a thirty-foot by seventy-foot space for Beverly's Pancake Corner. Another Beverly's opened at Northwest Twenty-third and Classen Boulevard in 1961.

Osborne would retire from the business in 1974, selling his interests to Shaw. His Chicken in the Rough franchise still exists at Palms Krystal Bar in Port

A menu from Beverly's Grill. *Courtesy Kyle Anderson.*

Huron, Michigan, and two McCarthy's Grill locations in Ontario, Canada. Beverly Osborne was killed in a tragic accident on his property in 1982. Beverly's Pancake Corner operates in Oklahoma City under Renee Masoudy.

Alice Stanley of Yukon shared memories of Beverly's in a story that ran on January 23, 2008, in the *Daily Oklahoman*:

> *In the very early '60s (I was in my very early 20s), I worked at the state Capitol. There was a fairly large Beverly's restaurant on Lincoln Boulevard just north of the Capitol building. We state employees were paid once a month, so on payday we would sometimes go to Beverly's as a special treat.*
>
> *They had a Mexican plate called "The Thing." One could ask for half an order, which came on a smaller plate. I can still remember the day our waitress came to the table and asked, "Which of you ladies has the small thing?"*
>
> *Judy, Ginger and I nearly fell out of the booth laughing.*

Chapter 10
FLAVORS OF THE WORLD

P ost–World War II America was the setting for the explosion of interest in ethnic cuisine. Jack Sussy is credited by most for introducing pizza to Oklahoma City's dining public. Les and Sam Nicolosi opened their Ranch House in 1944 and would spend the next forty years drawing fans for its interpretation of the Italian favorite.

But no specialty restaurant had as much impact on Oklahoma City dining as Luis Alvarado's El Charrito Café, which expanded to five locations in the decade following the war and planted the seed for El Chico of Dallas after the war.

EL CHARRO TO EL CHARRITO

For 35 years, our family had gone to Luis Alvarado's restaurants to celebrate birthdays, anniversaries, arrivals, departures and all other special occasions, including every Christmas Eve.
—Mary Goddard, 1987

Just before the war started, competition began to arrive for El Charro. In 1940, Frances Barrientos and her family opened El Patio at 417 Southwest Fifth Street, offering "delicious Mexican food, cold plate lunches, and sandwiches with curb service." Frances and her husband, Ernesto Jose,

The El Charrito in the Paseo Arts District was the crown jewel of Luis Alvarado's empire of Mexican eateries. *Photo courtesy Oklahoma Historical Society.*

An interior view of El Charrito in the Paseo District. *Photo courtesy Oklahoma Historical Society.*

eventually ditched the cold plate lunch, sandwiches and curb service to become a popular neighborhood café for more than thirty years.

But tragedy struck El Charro in February 1942 when Luis Alvarado took his beloved canary, Tony, outside to soak in a little sun. Alvarado put the caged bird out on the sidewalk, only to have the bedeviling Oklahoma wind blow the cage over, injuring Tony and "almost breaking Alvarado's heart." Alvarado carefully carried Tony up the street to St. Anthony Hospital, where "two understanding nurses and a physician came to the rescue." Tony had his right leg set and wrapped, and he underwent another exam the next day.

"It hurt, but I held him in my hands myself," Alvarado told the *Daily Oklahoman*. Hospital attendants at the time reported that Tony was the hospital's smallest patient to date.

Alvarado partnered with nephew Jesus Tello and Manuel Cruz for Café El Charrito at 2909 Paseo and followed that with Café Palacio at South Robinson and U.S. Highway 77 in Capitol Hill.

During the war, Alvarado's brother-in-law Willie Jack Cuellar joined North American Aviation plant in Dallas, staying until 1945. When he left, Cuellar was unsure he wanted to return to the restaurant business. But his sister and brother-in-law made it down to Dallas for a family gathering and talked Cuellar into coming to Oklahoma City.[29]

"I'll give you a restaurant," Alvarado said.

Cuellar and Tello took over management of the store on Paseo, by then known as El Charrito No. 1. In 1949, Cuellar left Oklahoma City to participate in a Dallas partnership with his four brothers on the El Chico restaurant they'd started. El Charro expanded to Wichita, Kansas, in 1948. El Charrito No. 2 opened at 113 North Walker in August 1951. It included murals that featured the Sleeping Lady volcano for a setting "that rivals in splendor the palace of a proud Aztec chief." El Charrito No. 3 followed at 2300 North Broadway.

Alvarado gained his citizenship on April 27, 1962. Two years later, he opened a sidewalk restaurant in the new Shepherd Mall. But by the end of the decade, El Charrito would be gone.

EL FENIX/EL RANCHO SANCHEZ

On January 20, 1950, it was reported that the "recently opened O'Mealey's restaurant at NW 22 and Broadway" had been sold to Mike Martinez and

his nine-member family, who owned and operated El Fenix in Dallas, for more than $100,000. Naomi O'Mealey said the new establishment she and her son Harvey had purchased, the former Gordon's Restaurant, the previous summer and remodeled completely hadn't been for sale. The new place opened only two months before the Martinez family made an offer that Mrs. O'Mealey found impossible to refuse.

"I want to welcome them to Oklahoma City," she told the *Oklahoman*. "And I'm glad to be able to devote all my time to the cafeteria."

El Fenix opened the following March and maintained a presence in the market for close to five decades.

Serapio Sanchez was born in Monterrey, Mexico, but moved to Austin, Texas, to raise a family. That's where his son Eulalio "Larry" was born, reared and grew up raising horses. Larry survived the Battle of the Bulge during a three-year stint in the army. After the war, he and his father tried and failed at two restaurant ventures in Austin before moving to Oklahoma City in 1954. Their El Rancho Sanchez would operate for the next forty-five years, serving Tex-Mex cuisine to south Oklahoma City. When the last restaurant closed in the early 1980s, descendants Janie and Jim Meadows decided to open their own and name it after her father, who died in 1979.

The first Don Serapio's restaurant was on May Avenue for more than eighteen years. The Meadowses would move to El Reno, where they still operate. John Sanchez, Larry's son, ran his own restaurant, Casa Juanito, in Del City until 2006, when he sold it. Casa Juanito serves in the same cafeteria style and offers the same menu as El Rancho Sanchez had.

JACK SUSSY AND JAKE SAMARA

On one special occasion my sweetheart (my husband) took me to Sussy's. He really wanted to impress me, so I could order anything on the menu. Of course, we were dressed in our best high school finery. When it came time to pay, his billfold was nowhere to be found. The owner, Jack Sussy himself, was notified. Benny said I could stay at the restaurant and he would drive home and get the money. Mr. Sussy wouldn't hear of it. He told us to go on our way and come back the next day to pay. We often returned to Sussy's and were always warmly greeted by Mr. Sussy.
—Mrs. Benny (Sandy) Brown, 1999

Jack Sussy came to Oklahoma City from Chicago and became a legend in the local restaurant industry. *Photo courtesy Oklahoma Historical Society.*

Pete's Place and Minnie's had drawn folks all the way to Pittsburg County long before the war. The establishments featured fine Italian food, fried chicken, steaks and lamb fries. One Pittsburg County native, Frank Peccio, attempted to bring a taste of Krebs to Oklahoma City with Casablanca in 1946, but what stuck was pizza. And it took a Jewish guy from Chicago and a Lebanese guy from Waynoka to introduce it to the masses.

Jack Sussman was a Chicago gambler who blew into town looking to roll the dice and ended up doing so in a game with odds stacked against him. Sussman grew into legend, but no one would've heard of him without Jake Samara, who was unafraid to work propriety's fringes. Samara grew up in Oklahoma City, graduating from Central High School. After business college, Samara became a bookkeeper for Armour Meat Company and boxed for fifty cents a fight at the Stockyards Coliseum to earn money to open his own business.

"I sold the bar for $800 and bought the old Quality Barbecue place on Northeast 23rd Street," Samara told columnist Max Nichols. "I changed it to Jake's Barbecue."[30]

Jake Samara was as comfortable in the police station as he was operating one of his nightclubs and restaurants. *Photo courtesy Oklahoma Historical Society.*

The place went from Jake's Barbecue to Jake's Night Club and started bringing in touring acts. Brushes with the law were common. In 1939, Samara was cited for operating a slot machine in the club.[31] That didn't stop him from airing a live program on KTOK radio in 1940. After that, he changed the club to western-themed Jake's Cowshed. When, in 1947, Jake's Cowshed had its license revoked for allowing dancing in an establishment where beer was sold, Samara was forced to get creative. So, he reopened under the name Jamboree Supper Club, which required members to pay a $32.12 initiation fee and $7.31 per month in dues. Privileges included dining, dancing and a bartender to mix drinks.

The Jamboree featured striptease acts. In 1947, the law came after the establishment for a performance by Los Angeles–based burlesque dancer Evelyn West that included a male dummy.

Samara told reporters, "We don't cater to a prudish class at our night club and our spectators are all adults and liberal-minded."

A place that featured gambling and girls was like sugar to a fly for Jack Sussman. According to a 1999 interview with Jake's brother Mike Samara, Jack Sussman's wife was an exotic dancer at the Jamboree Club. Jack and Jake struck up a friendship and agreed to partner on an Italian restaurant, at Sussman's wife's request, at 629 Northeast Twenty-third, across the parking lot from the club.[32]

"Jack, since you're Jewish and I'm Lebanese, we need an Italian name," Jake said. "We'll name the place Sussy's, and I'll start calling you Sussy."

Sussy's Italian Restaurant, also called Sussy's Italian Pizzeria, opened in February 1949, and the partnership lasted until the early 1960s, when the state bought all the land north of the Capitol, which also included Beverly's Drive-In, to construct office buildings.

Mike Samara said most of the recipes came from Jack's wife, who was Italian, and that they frequently imported cheeses from Italy to ensure quality. Dot Curry said she began working in Sussy's kitchen when it opened and for the next twenty years. She said Sussy brought a chef in from New York City, a native of Naples, Italy, to train the staff how to make pizza, antipasto plates, Italian salad bowls, lasagna, Italian meatballs, ravioli, veal scallopini and chicken cacciatori—all made with Sussy's original sauce.[33] Pizza was not only exotic and delicious, but it was also easily packed for takeout, which increased its popularity exponentially. Jake and Jack had a hit on their hands, and the money coming in from the club was considerable, too. Even a gunshot wound Sussman incurred during a robbery in 1953 couldn't slow momentum. Sussy's Italian Restaurant No. 2 opened on July 6, 1956, at 9014 North Western Avenue, where Baker's Printing stands. That same year, they began selling frozen versions of Sussy's pizza and boil-in-the-bag spaghetti and meatballs.

Later that year, Sussman announced plans to open a grand restaurant and club called the Sirloin Strip Steakhouse. He told the *Daily Oklahoman* it would have capacity for three hundred patrons divided among three dining rooms in the 7,700-square-foot space with pink brick exterior, a large lobby, a lounge and a stainless-steel kitchen. By the time the building was completed, Sussy decided to call the restaurant Jack Sussy's Italian-American Restaurant and Steakhouse. He opened another Sussy's in Norman, on Highway 9 in the old Redwood Inn, in 1959.

Jack Sussy's was eventually carved into three spaces for a liquor store and the Nomad Club in the 1960s. In 1966, arsonists did heavy damage to the

Jack Sussy shakes hands with President Harry S. Truman. *Photo courtesy John Bennett.*

building but even worse damage to Jack Sussman. The arsonists implicated Sussman, leading to first-degree arson charges that went to trial. However, the judge ended the proceedings in a mistrial in September 1967. Despite being implicated by the arsonists during testimony, Sussman avoided conviction. However, he found himself financially crippled. He rallied to open Sussy's Tally-Ho Restaurant at Northwest Thirty-sixth and Lincoln in 1968, featuring pizza, spaghetti, chili, tacos, hot dogs, burgers and pies. A few months later, the building that burned was sold at auction for $100,000.

Sussman opened a Sussy's at Southwest Twenty-fourth and Robinson in 1967. It included Club Stage Door, which featured go-go dancers, in the back. The Captain's Table seafood restaurant was opened in 1969. He also had a stake in Casa Mia Italian Restaurant in 1969, which featured strip bar Club Barbarella, in a location next door to the present-day Red Dog Saloon. He hosted dinner at SPQR Italian Restaurant in Quail Plaza in the early '70s. Mario's in Casady Square sold Jack Sussy's Famous Pizza plus lasagna, manicotti and steaks in 1973. About that same time, he opened Jack's Happy Days Grill, which he would sell to a young ambitious restaurateur named Bob Sullivan.

All that hustling led to a new place, which in turn led to an ad in the *Daily Oklahoman* in April 1975 that read, "The Original Jack Sussy Now at

73rd and N May would appreciate a visit from my old and new friends." Visits obviously were mostly from old friends, because Sussman was arrested in September of that year, accused of conducting illicit gambling at his apartment on Northwest Fifty-sixth.

Sussman died in 1980. The Nomad II on Northwest Seventy-third and May is owned and operated by Rick Bailey today.

After losing his spots to the Capitol complex, Jake Samara faced a series of financial challenges while tap-dancing around the law with various clubs. In 1977, he resurfaced with the Spaghetti Factory concept in the Paseo Arts District in a space where he and Sussman had previously stored their frozen pizzas. It lasted about ten years. Samara died at the age of ninety-two.

Hideaway Pizza

The most popular homegrown pizza place in Oklahoma City opened in 1957 in Stillwater. Richard Dermer worked as a delivery driver for the pizza place in a brick house across from the Oklahoma State University campus called Hideaway Pizza. When the Kansas company that owned the place faltered a couple of years later, Dermer and his wife, Marti, purchased it. They developed it into a must-stop in Stillwater. Four decades later, three former Hideaway managers who worked their way through OSU approached Dermer about expanding the concept. One of the interested parties was Gary Gabriel, inventor of the board game Pente. Dermer wasn't interested, but he agreed to allow his former employees to start Hideaway II, Inc. The original company was sold in 2006 to Brett Murphy and Darren Lister of Bartlesville, who continue to own locations around the state, including seven in and around Oklahoma City.

Nicolosi's

One of my fondest memories of Nicolosi's was as a kid, going up to pay with my late Dad and having him sit me on the bar, giving me a pack of Fruit Stripe Gum and listening to Les and Dad talk about the old guns that hung over the bar.
—Ron Herendeen, 1999

Les Nicolosi serves a plate of spaghetti and meatballs to Mrs. Mabel Clare Knight at the family restaurant he owned with his brother Sam. *Photo courtesy Oklahoma Historical Society.*

Pietro Nicolosi, an Italian immigrant, moved to Oklahoma in 1906 to raise cotton in Fort Cobb. A year later, he fetched his bride, Rosa Lea, from Illinois, and the couple started a family: two sons, Les and Sam, and a daughter, Armida. In 1921, the Nicolosis moved to Oklahoma City, where Pietro bought ranch land near Northwest Tenth and Portland.

In 1948, Les and Sam Nicolosi purchased a restaurant not far from the homestead on the corner of Northwest Tenth and May, where they spread red-and-white-checked tablecloths and became famous for pasta at

Nicolosi's Ranch House Restaurant. In 1954, they lost their corner to the state fairgrounds, forcing a move to 5000 Northwest Tenth. There, they added Neapolitan pizza to the menu. Les Nicolosi said the pizza recipe and style were a joint venture worked out by the brothers, paisan Tony Minicosi and a French chef from Louisiana, Martin Talley, who figured out the crust.[34]

For twenty years, Mama Rosa Lea made the sauce and the meatballs from her secret recipes at home and shipped them over to the restaurant every day. Her sister Armita Dunn picked up where Rosa Lea left off for the next two decades.[35]

The place developed a faithful and sentimental following. "A lot of them had their first dates here," said Mary, Les's wife. "They carved their names in the booths and when they came back they wanted to sit in the same booths and show their children the names."

"This started when we were young fellows," Les said in 1988.[36] "We bought our first car together. We dated together. Nearly everything we did was between Les and Sam. We've had our squabbles, but there were never guns or knives or fists. I never did try to boss him and he never tried to boss me. He'd come to work and do his job and if he didn't have time to do it all I'd go in there and do it. We all showed up to work. We kept our mouths shut and kept going forward."

Sam and Les retired in 1988, selling the restaurant to Mary Harris and Judy Metz. At their retirement party, about five hundred people packed into the restaurant; the next day, phone calls informed them that many more had come by but couldn't get into the parking lot.

Sam died on Christmas Day 1995 at age seventy-nine; Les died on Christmas Eve 1996 at the age of seventy-eight.

TONY'S VIA ROMA

Tony Lazzara opened Tony's Via Roma on Northwest Expressway in 1960. Lazzara came from Chicago, where he'd made friends with George Fong, who convinced him that Oklahoma City could support a new Italian concept.

So Lazzara and his wife, Fran, moved their young family to Oklahoma and opened in a white building with Roman flourishes between May Avenue and the Charcoal Oven. The lobby was decorated with black-and-white family photos. Linen-covered tablecloths filled the low-lit dining room populated by Chianti bottles corked with drip candles.

When Tony died in 1970, Fran bought out Fong and carried forth, moving in 1988 to Spring Brook Shopping Center near a different Charcoal Oven. She sold the restaurant in 1989. It closed a few years later.

NED'S STEAKHOUSE

Ned's Steakhouse on North May was best known for its pizza. Ned Mutz was a meat salesman before he and his wife, Frances, bought a hamburger place at Northwest Twelfth and Hudson called Ned's Grill. They later opened two more, at Northwest Twenty-third and Walker and at Northwest Sixteenth and Portland. The cafés operated throughout the 1940s and into the 1950s.

In 1953, they bought the steakhouse near Classen High School from Charlie Dunning, who was best known for his fried chicken. Frances fell in love with pizza in Chicago and thought it would go over in Oklahoma City. She was right. As soon as she started offering it at the steakhouse, it proved to be the restaurant's top seller. Frances made her own sauce and had cheddar and mozzarella cheeses flown in from Chicago.

Ned and Frances divorced in 1967. He died in 1968, and Frances passed in 1970, after which their son Mike ran the place for at least another decade.

Chapter 11
FROM THE PITS TO GREAT HEIGHTS

THE HICKORY HOUSE

One of the world's most storied culinary careers began in a red-dirt-colored, two-story building on the northeast corner of Southwest Twenty-fifth and Western. The intersection was one of the busiest in town when John Bayless and his wife, Levita, opened the Hickory House there in 1952.

"We opened with money in the register and our inventory, that's it," Levita Anderson said in 2010. "We served three generations of customers in that building."

While the Hickory House served those generations, it also served as culinary school for their youngest son, Rick.

Without the Hickory House, Chicago wouldn't have Frontera Grill, Topolobampo or Xoco. Grocers across the country wouldn't have the Frontera Foods line to sell, nor would we have seven cookbooks and ten seasons of *Mexico: One Plate at a Time* to enjoy.

Levita raised three wildly successful children. She worked at a bank out of college. It was there she found opportunity.

"The bank president said we had a lot of money to loan and asked me what kind of place would be good to invest in," Levita explained in an interview for the Oklahoma History Center in 2014. "I told him I thought a barbecue joint, and he said, 'Why don't you open it yourself and the bank will loan you the money?' So that's what we did."

Above: Levita and John Bayless at the Hickory House. *Photo courtesy Rick Bayless.*

Left: The Hickory House was a cornerstone of local barbecue for more than three decades. *Photo courtesy Rick Bayless.*

A Hickory House ad in the *Daily Oklahoman* from June 1952 reads: "John, Levita & John Jr. invite you to take home a feast for 2." The feast included a pound of ribs, a half pint of beans, potato salad or slaw and sauce for $1.70—prepared while you wait.

Rick Bayless was still about eighteen months from birth when that deal was available. John Jr. was a toddler and would never be drawn to the family business or even maintain the name John Jr. His dad called him Skipper, Skip for short.

"Skip never cared anything about food," Levita said. "But Rick just had such a passion for it. I always tell people I've got one son who lives to eat and another who eats to live."

Skip Bayless is one of the most successful sportswriters in the country. He's worked across the country and appeared on ESPN's *First Take* and *1st and 10*. Levita says her children got their intellect from their father.

"John was extremely intelligent," she said. "He had a mind for engineering. Any equipment he couldn't find, he built."

During football season, folks headed to Norman on Saturdays had to drive right past the Hickory House at Southwest Twenty-fifth and Western. As traffic came to a standstill, Levita, Rick and daughter LuAnn were out on the sidewalk selling sacks of barbecue sandwiches.

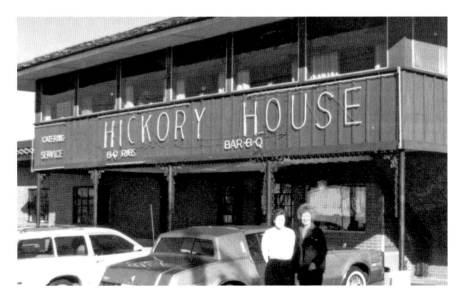

A look at the exterior of the Hickory House, owned by the Bayless family. *Photo courtesy Rick Bayless.*

LuAnn is a national board-certified special-education teacher who has been in the Edmond school system for years, and whispers abound that she might be the best cook in the Bayless brood. "LuAnn makes delicious food," Levita said.

Levita didn't let her responsibilities at the Hickory House stop her from becoming PTA president at Northwest Classen High School in the 1960s. And when alcoholism claimed her marriage and then her ex-husband's life in 1975, Levita pushed through and ran the Hickory House on her own its last twelve years in business.

During his junior year, Rick ran the catering operation and did well enough in school to graduate that year. He spent his first year of college at Oklahoma City University because "they were the only school that would take me that

Rick Bayless dances with his mother, Levita Anderson, at the eightieth birthday party he threw for her at the Metro Wine Bar and Bistro in 2006. *Photo courtesy the* Oklahoman.

young" before transferring to the University of Oklahoma, where he tested out of his senior year of high school and earned a degree in Spanish cultural studies at age twenty. Young Rick Bayless went north for graduate school at the University of Michigan, where he eventually changed the course of American dining, creating the vanguard for interior Mexican cuisine at Frontera Grill and the concepts that followed.

When the Hickory House closed in 1986, Levita helped Rick and his wife, Deann, open Frontera Grill in Chicago. At age fifty, she took up golf and recorded three holes-in-one. When her son who lives to eat comes to town, he starts each trip at Johnnie's Charcoal Broiler. Once he's had his burger, fries and onion rings, the visit can commence. For his mother's eightieth birthday in 2006, Bayless leased Chris Lower's Metro Wine Bar and Bistro and brought a sous chef and all the food to bring Frontera Grill to his mother. LuAnn baked the cake, and the party lasted six hours.

"I was so touched," Levita said. "He's just such a sweet boy."

Tom's Barbecue

Tom Norman opened a barbecue joint in an old Colonial-style house in 1960. When it burned down in 1974, it was replaced with a modest building. Tom's wood-smoked brisket, ribs and pork built him a strong reputation into the 1970s, when the restaurant was in its heyday. He ran the business along with his wife, Blanche, and hired Artie Green in 1979.

"Tom was a good man," Artie told *Oklahoma Today* in 2008. "He was like a father to me."

Green said that Norman took him out to the pit and showed him how to build a fire and cook with it, beginning a thirty-year stint as pitmaster.[37]

Blanche died in 1996, Tom in 2002. Artie carried on for about another decade before Tom's quietly closed.

Glen's Hik'ry Pit and Glen's Hik'ry Inn

Growing up, when we received good report cards, the whole family would go to Glen's. What great memories we had there!
—Allison Hart Bowlan, 1999

Chef Doug Henley flips a steak, which were the signature of Glen's Hik'ry Inn. *Photo courtesy Oklahoma Historical Society.*

Glen Eaves and Hank Abney tried and failed at hamburgers, barbecue and cafeterias before they found success in the restaurant business.

"Dad and Glen built and ran several restaurants around Oklahoma City together. Among these was an employee's cafeteria at the old Sears and Roebuck at NW 23rd and Villa," according to Stephen Abney.[38]

With little more than his butcher's skills to fall back on, Eaves opened a small grocery store and butcher shop on Northwest Tenth Street, just around the corner from the state fairgrounds, in 1946. Eaves installed a barbecue pit and began selling smoked meats with enough success that two years later he and his wife, Alleene, opened Glen's Hik'ry Pit, with Abney and his wife, Margaret, as partners. Business was good enough to open another restaurant across the street in 1952, selling the same barbecue menu while expanding it little by little. In 1953, a sign reading "Glen's Hik'ry Inn" went up over the space at 2815 Northwest Tenth. The new place opened its doors on April 27 of that year. A line formed about a half hour before opening for the filet mignon, K.C. strip sirloin and barbecue pork ribs.

An account of the grand opening read: "Traffic on the western edge of the city was snarled for miles Monday night as hundreds of hungry Oklahomans flocked to the grand opening of Oklahoma City's newest and finest steakhouse."

Glen's Hik'ry Inn became one of Oklahoma City's most revered steakhouses, the first to introduce charcoal-broiled steaks plus fried chicken, South African rock lobster, lamb fries and charcoal broiled shrimp. The garlic coleslaw was a best-selling signature, and relish boats included rose radishes, huge black

SPECIAL DINNER SUGGESTIONS

COUNTRY FRIED CHICKEN
Hot Biscuits and Gravy
OLD FASHION SKILLET FRIED

CHARCOAL BROILED CHICKEN
Served with Salad Bar and a Choice of Dressings,
Baked Idaho Potato with Sour Cream,
Hot Rolls and Butter and Relish Bowl.
3.95

BAR-B-Q PIG RIBS

GENUINE LAMB FRIES

CHICKEN LIVERS SAUTEED en BUTTER

FRENCH FRIED OYSTERS

CHARCOAL BROILED SHRIMP

FRENCH FRIED SHRIMP

PAN FRIED IDAHO TROUT

BROILED FROG LEGS

ASSORTED FISH PLATTER

FILLET OF STUFFED FLOUNDER

Serving Bleu Cheese Dressing

Served with Salad Bar and a Choice
of Dressings, Baked Idaho Potato with
Sour Cream, Hot Rolls and Butter
and Relish Bowl.
6.25

APPETIZERS

LARGE SHRIMP COCKTAIL	1.95
OYSTER COCKTAIL	1.50
MARINATED HERRING	.75
FRENCH FRIED ONION RINGS	.75
CHARCOAL BROILED SHRIMP FOR TWO	4.95
CONSOMME - HOT or COLD	.50
OYSTERS ON THE HALF SHELL (12)	2.95

GRILLED TENDERLOIN STEAK
LADIES SPECIAL

Served with Shrimp Cocktail,
Salad Bar and a Choice of
Dressings, Baked Idaho Potato with
Sour Cream, Hot Rolls and Butter
and Relish Bowl
6.50

COMPLETE LOBSTER DINNER
Two Lobster Tails, Broiled

TASTY BABY SOUTH AFRICAN
LOBSTER, DRAWN BUTTER
Served with Relishes, Salad Bar,
Potatoes, Rolls and Butter

When **9.95** Available

STEAK and TAIL DINNER
LOBSTER TAIL BROILED
1—6 OZ.
TENDER LOIN STEAK GRILLED
2—CHICKEN LIVERS
SAUTEED IN BUTTER

Crisp Salad Bar, Choice of Dressing
Baked Potato or French Fries
Relish Bowl Hot Bread and Butter

When **9.95** Available

CHARCOAL STEAKS

Long Island Oysters "R" always in season.
Always in season, always plump and plenty,
with a tang of salt spray are our best.
Long Island Oysters on the Half Shell.

HEAVY AGED ED BEEF

	1.50	
	.75	
Broiled Throughout	CORN ON THE COB	.50
WELL DONE No Juice Left	CHARCOAL SHRIMP FOR TWO	4.95
	LARGE SHRIMP COCKTAIL	1.95

ROAST PRIME RIBS OF BEEF
Complete Dinner
Served with Salad Bar and a
Choice of Dressings, Baked Idaho
Potato with Sour Cream, Hot Rolls,
Butter and Relish Bowl
8.50

Coffee or Tea — .25

1 - **BLUE RIBBON, U.S. Prime Heavy Aged Beef Filet**
House Special - The Pride of the Hik'ry Inn 7.95

2 - **CHOICE CLUB, Cut From the Top "Sir-Loin"** 6.50

3 - **KING SIZE CLUB, Lots of Luscious Eating**
One of Our Very Best 7.50

4 - **CHOICE T-BONE STEAK, The Rancher Special** 7.95

5 - **TEXAS T-BONE STEAK, Real He-Man Size (Porterhouse)** 8.95

6 - **KING SIZE K. C. STRIP "SIR-LOIN", Recognized**
as the World's Best Steak, Center Cut 8.50

7 - **CHOICE RIB-EYE STEAK, Lots of Good Eating** 8.50

8 - **"SIR-LOIN" STEAK KABOB, Tender Morsels of Choice**
Beef, Marinated in Wine and Fine Herbs 6.25

9 - **U.S. PRIME BEEF CHOPPED "SIR-LOIN",**
Bacon Wrapped - None Better 4.95

10 - **LAMB CHOPS, Tender Young "Sir-Loin" Cut** 6.95

CHARCOAL BROILED PORK CHOPS,
Tender and Delicious 5.95

Serving Bleu Cheese Dressing
Above Served with Salad Bar and a Choice of Dressings, Baked Idaho Potato
with Sour Cream, Hot Rolls and Butter, Relish Bowl.

Gold Platter - N-Knife Steak
PRIME NEW YORK CUT "SIR-LOIN" STEAK
Served with Shrimp Cocktail, Salad Bar and a Choice of Dressings, Baked
Idaho Potato with Sour Cream, Hot Rolls and Butter, Relish Bowl
Men's Special Dinner 7.50

A look inside the menu at Glen's Hik'ry Inn. *Courtesy Kyle Anderson.*

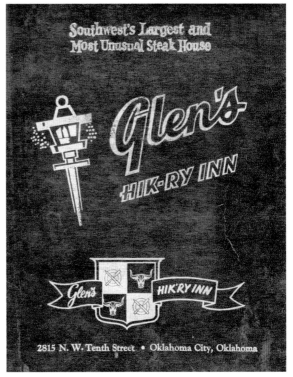

Southwest's Largest and Most Unusual Steak House

Glen's
HIK-RY INN

Glen's HIK'RY INN

2815 N. W. Tenth Street • Oklahoma City, Oklahoma

A look at the dining room inside Glen's Hik'ry Inn. *Courtesy Kyle Anderson.*

olives and pickled watermelon rind. Knowing the value of a good butcher to a steakhouse, Eaves kept two full-time butchers on staff to cut steaks. Glen's was also among the first to get a permit to operate a private club for the purposes of serving alcoholic beverages. Eaves also understood the value of ambiance, keeping a silver collection on display at the front as well as raw steaks on ice. The rustic wood walls were adorned with guns and equine artwork, and the space featured red booths and brown tablecloths. In June 1957, Eaves introduced the first smorgasbord, offering one hundred items. Glen's Hik'ry Inn blossomed to national prominence. A 1977 survey listed Glen's as eightieth on a list of the top five hundred independently owned restaurants.

The secret to Eaves's success, according to his former catering manager Terry Sanchez, was quality. "Glen's bought nothing cheap. It was always top grade meats. As for catering, the food was always fresh," Sanchez wrote in 1999 in a letter to the *Oklahoman.*

Eventually, Abney opened his own Hank's Hik'ry Pit on May Avenue, just south of Interstate 44, which operated until 1969. Margaret also operated the Éclair restaurant, an all-night café on Northwest Thirty-ninth Expressway. She eventually sold the Éclair to Bob and Lola Steckler, and it later became home to Meiki's Italian Restaurant.

Glen died in 1980 at age sixty-four. Alleene continued the business until November 1985. The Hik'ry Inn burned down on Christmas Day 1989.

Chapter 12
BREEDING GROUND FOR HOODLUMISM

Police Saturday moved in on taverns, pool halls and troublesome drive-ins "to get at the breeding grounds" in curbing rampant teen-age hoodlumism in Oklahoma City.
—the Oklahoman, *1959*

About thirty thousand drive-in eateries were in operation in 1959. It was estimated that three out of every five new restaurants at the time were drive-ins, accounting for about one-third of the money spent in U.S. restaurants.

"Tis the Taste that Tells the Tale" was the proclamation at Garland's Drive-In, which operated from 1939 to 1950, plus a second location at 537 Southwest Twenty-ninth. Owner Garland Arrington had just finished running the Capitol café. The art deco building featured a tower and popular corner entrance. The inside dining room had walls covered in floral paper and wrought-iron furniture. The restaurant offered curb service. In the early days, carhops wore sailor outfits, short skirts and white boots.

For two decades in the middle of the twentieth century, youth—troubled or looking for trouble—could spend a summer night cruising down Classen Boulevard to Quick's on Northwest Thirty-second Street for nineteen-cent burgers served beneath a hyperbolic paraboloid roof. Laying a scratch on the way out, the next stop was Bixler's drive-in on Northwest Twenty-third to park and watch the procession of idling cars creep along in a haze of exhaust and rock 'n' roll. Cruising was present in all sectors of town, each with its own set of drive-ins and protocols. Kids in south Oklahoma City connected at Coit's in Capitol Hill or Potter's in Midwest City. On the northeast side

was Carp's. Cherry's was another popular spot. Others included Goode's, Flying Chicken, Mainey's, the Tower, Wood's and Valentine's. Marsh's Drive-In, which previously had been a Marsh's Pig Stand, joined Garland's on Broadway, south of Northwest Twenty-third. Garland's was closed before Marlow's would open at 1600 North Broadway in 1955 and become Broadway Drive-Inn by 1964.

Today, Charcoal Oven, Del Rancho and a handful of others still operate. Sonic Drive-In is the biggest drive-in chain still operating in the United States and calls Oklahoma City home. The nationwide franchise began in Shawnee and blossomed in small towns around the state before coming to the big city in the 1970s.

THE SPLIT-T

In 1965, the two big hangouts on the north side [were] the Split-T and the Charcoal Oven. Northwest Classen hung out at The Oven, but John Marshall and Harding claimed the Split-T. Not wanting to start the relationship on the wrong foot, I decided to take her to the "T" and see who was there.

As always, the traffic around the "T" was like a parking lot. At that time, there were car stalls and carhops to deliver the food. If you were cruising, you had to eat outside so you could see and be seen. Well, it must have taken thirty minutes to finally turn into the parking lot, then circle around a couple of times and find a place to park. But was it worth it! A prime spot near the side entrance where I could wave to the few people that I knew but could be seen by everyone else. This had to be the best first date ever.
—Gary Bartley, 2000

When Ralph and Amanda Stephens moved to California, they left middle son Vince at the University of Oklahoma, where he was a member of the RUFNEKs cheer squad, affording him an up-close view of Coach Bud Wilkinson's split-T offense. While at the annual Red River Rivalry game in Dallas, Vince was asked by a pretty Texas coed what he did. The story goes that Vince told her he owned a restaurant called the Split-T back in Oklahoma City. It was a lie when he said it, but in 1953, he turned the fib around.

According to a 1993 story in the *Oklahoman*, a friend suggested splitting the front doors with a "T," which he did. As for the food, he copied the burger-joint formula set forth by family friend Ralph Geist at the Town Tavern in

Norman for the Theta house, which included hickory sauce, mayonnaise, pickles and cheese.[39]

When Vince Stephens added drive-in service in the lot south of the Split-T, he caught lightning in a bottle. The Split-T became a second home to teens from Bishop McGuinness, John Marshall, Harding, Casady and other local high schools.

Perhaps Stephens's most successful move was whom he hired as his first manager: a recently discharged army cook who'd been working at the airport's Sky Chef restaurant named David Nathaniel Haynes. He went by his father's name, Johnnie.

With Stephens wishing to spend more time with his family in California, Haynes became the de facto proprietor of the Split-T. He was fast, efficient and expected his customers to follow suit.

Paul Seikel, a John Marshall graduate, hung out there long before he opened his first restaurant. He said, "You had better be able to run a 4.4 forty when Johnnie called your name."

In 1979, Haynes left to open his own place, which carried a mirror-image menu, and the Split-T would begin a slow descent. Stephens eventually carved the space in half to add the T-Bar, which became a hangout for members of the state legislature. Former Oklahoma State star Rusty Hilger became a partner in the 1980s, but he was later embroiled in an embarrassing sting operation for illegal drugs in Norman that hurt business. In 1994, Brad Vincent and Chad O'Neill purchased the Split-T, learned the recipes from Vince Stephens and operated the restaurant until it closed for good in 2000.

The original building was razed in 2010. Today, a Sonic Drive-In sits on the property where the Split-T's carhops once skated. A small strip mall occupies the land where the Split-T and T-Bar stood.

HOLLIE'S

Hollie's Drive-In was opened in 1947 by Edmond and Evonne Hollie, who bought the Shady Tree Tavern and turned it into a drive-in hamburger and fish-and-chips restaurant. Evonne ran the place with an iron spatula and occasionally a rolled-up newspaper. One night a young man howling at the moon from the hood of his car found out.

"The wife picked up a rolled-up newspaper. She walked around and slapped him across the neck and nearly knocked him down," Edmond said in 1981.

Hollie's was known for its Big Bacon Burger. A sassy swine in pinstriped overalls leaned over the neon Hollie's sign.

"I worked that out in about 1951," Hollie said. "I wanted something different. I worked on it till it tasted like I wanted it. I slipped it onto the menu and people came around by word-of-mouth."[40]

The big pig first appeared in 1955, beckoning restless youth with its puckish snout and crossed porky ankles.

When Evonne contracted cancer in 1970, Edmond leased the iconic drive-in to up-and-coming operators Dick Stubbs and David Egan, who had successfully operated similar concepts in Stillwater and Oklahoma City. But Hollie bought the property back in 1978. Evonne died in 1980, and Edmond closed the drive-in the following year.

Jerry Hilterbrand bought the original sign in 1985 and opened Hollie's 50s and 60s Club and Diner until 2003.[41] Today, the Hollie's sign stands inside the Hal Smith concept Hollie's Flatiron Steakhouse in Moore.

CHARCOAL OVEN

The smiling chef in the white hat has held the words "Charcoal Oven" above his head in cursive neon for nearly sixty years. Before he opened the Oven, owner David Wilson owned Quick's.

A "Welcome to Charcoal Oven" archway in red neon greets drivers who pull up to a miniature version of the chef sporting a menu on his chest.

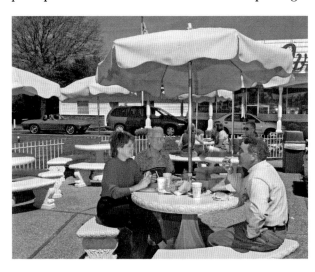

Charcoal Oven is a drive-in but also has patio dining. *Photo courtesy Oklahoma Historical Society.*

A two-way loudspeaker at the chef's navel is where you make orders for a Chick-A-Doodle-Doo fried chicken sandwich, Suzy-Q fries and "hamburgers the way dad cooks 'em—big and juicy."

When Charcoal Oven opened on May 8, 1958, business was slow, but when the Penn Square Shopping Center opened in 1959, a half mile to the east, sales picked up. The Charcoal Oven once swelled to four locations. The original closed in September 2016, looking as immaculate, with its pristine landscaping, as the day it opened.[42]

DEL RANCHO

Rosamond Holt finally convinced her husband, J.R., to sell his real estate business of more than fifteen years after their third restaurant proved to be a charm.

Their first restaurant, at 3300 South Western Avenue, was originally the Ranch House. The nearest competitor was the Hamburger Spot, which Del

Del Rancho was founded by the Holt family in 1961. *Photo courtesy the* Oklahoman.

Rancho outlasted by decades. The second restaurant, in Del City, became the first Del Rancho. From there, the couple opened two more and started selling franchises.[43]

Rosamond Holt said they sold their first hamburger for a quarter. When McDonald's came in 1964, it sold burgers for fifteen cents. That also happened to be the year Del Rancho introduced the Steak Sandwich Supreme, which came to J.R. in a dream in 1961 but took three years to perfect.

"Everyone said they'd break us, but we never felt it. We have a different menu. No one else has a steak sandwich like ours. We still hand make our onion rings. The competition has never really bothered us," Rosamond Holt said.[44]

The Holts' daughter Rosamond Jones and her husband pushed growth as far as Clinton and Tahlequah. Her children would eventually take it into Texas for a few years. At one time, the Joneses owned sixteen Del Rancho stores.

More than ten Del Ranchos still operate in Oklahoma, seven of them in the metro area.

Coit's

Don Coit opened the first of three drive-ins in 1954 in Capitol Hill, at Southwest Twenty-fifth and Western Avenue. The first location was a Weber's root beer stand with a shutter board instead of a window. Winter business was always slow, until Coit had the idea to add a Christmas tree lot on the property during the holiday season.

The operation grew; the root beer stand ditched Weber's for a formula of its own and transformed into a drive-in restaurant. Coit opened two more drive-ins at Northwest Thirty-ninth and Pennsylvania and at Northwest Fiftieth and Portland. Coit bought more real estate, including the Coit Center shopping plaza across from his Northwest Fiftieth location.

By the 1980s, the Coit's logo with the Christmas tree atop the "i" was a local fixture. The Christmas tree operation expanded to a vacant lot at the corner of Northwest Expressway and what is now the Lake Hefner Parkway, flourishing until the owner's death in 2005.

Coit's widow, Jesse, put all the properties up for sale in 2012, each closing one after another. A Coit's Food Truck is all that remains of the concept today.

The Kaiser's Ice Cream sign remains despite the establishment's latest incarnation closing in 2016. *Photo by Dave Cathey.*

Jim Mihas and son-in-law Ronnie Turk operate Coney Island in downtown Oklahoma City. It opened in the 1920s. *Photo courtesy the* Oklahoman.

Bill Schroer and Susan Vickers embrace on the final day of operation at the Queen Ann Cafeteria, located beneath Founders Tower. *Photo courtesy the* Oklahoman.

Pies were a benchmark of the Boulevard Cafeteria from 1948 to 2015. *Photo courtesy the* Oklahoman.

Opposite, top: The Lunch Box served downtown Oklahoma City for more than sixty years. *Photo courtesy the* Oklahoman.

Opposite, bottom: Jim Meadows stands next to a portrait of his grandfather at Don Serapio's. *Photo courtesy the* Oklahoman.

The Split-T quit serving Theta and Caesar burgers for good in 2000, forty-seven years after it opened. *Photo courtesy the* Oklahoman.

Charcoal Oven is the oldest of Oklahoma City's locally founded drive-ins in operation. *Photo courtesy the* Oklahoman.

Opposite: Hollie's Drive-In was known almost as much for the pig on its sign as for its bacon burger. *Photo courtesy Oklahoma Historical Society.*

Florence's Restaurant, opened in 1952, still serves fried chicken and honey meatloaf today. *Photo courtesy the* Oklahoman.

A look from the second floor of the Haunted House, now J. Bruner's at the Haunted House. *Photo courtesy Oklahoma Historical Society.*

J. Bruner's at the Haunted House opened in 2015, just months after owner Marian Thibault died and the restaurant was put up for auction. *Photo courtesy the* Oklahoman.

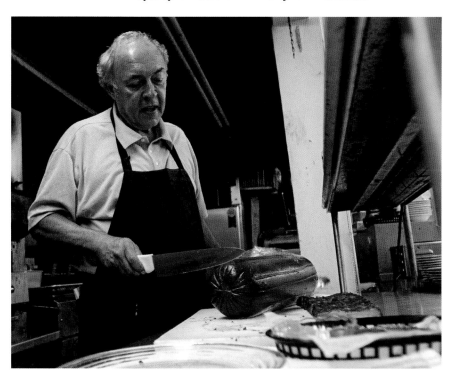

Greg Gawey slices the smoked bologna at Jamil's Steakhouse. *Photo courtesy the* Oklahoman.

Steak and potatoes from Jamil's Steakhouse. *Photo courtesy the* Oklahoman.

Middle Eastern mezzes at Jamil's include tabouli, cabbage roll and vegetables with hummus. *Photo courtesy the* Oklahoman.

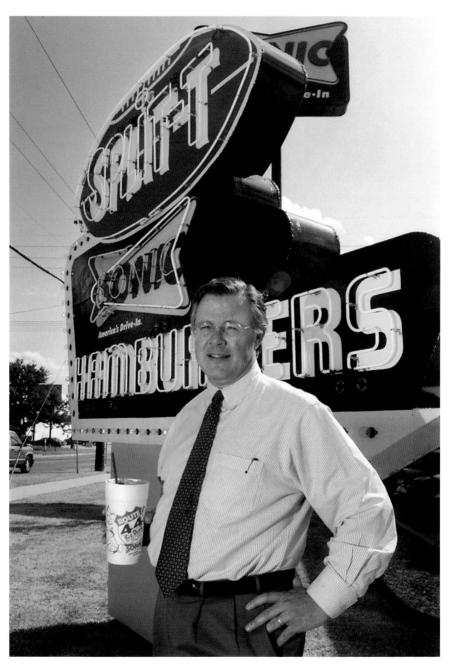

Cliff Hudson is chief operating officer of Sonic Corporation. Here, he poses at the location that took over the former Split-T Grill. *Photo courtesy the* Oklahoman.

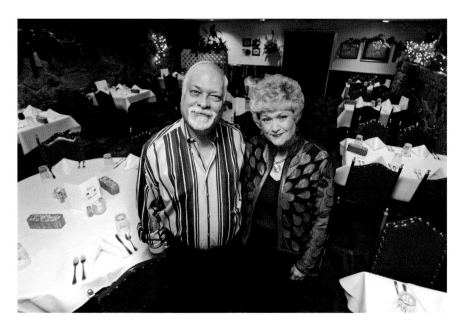

Chris and Pat Elias owned and operated Eddy's Steakhouse for decades. *Photo courtesy the* Oklahoman.

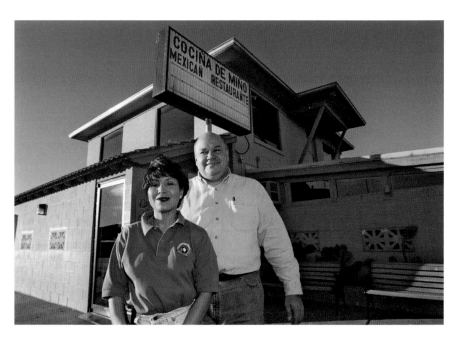

Leticia and Mario Hernandez of Cocina de Mino. *Photo courtesy the Oklahoma Historical Society.*

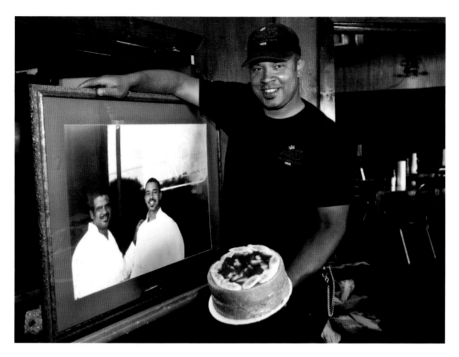

Charles Smith shows off one of Leo's Barbecue's famous strawberry-banana cakes standing next to a photo of him with his father. *Photo courtesy the Oklahoma Historical Society.*

Charles Smith goes on camera with Guy Fieri of *Diners, Drive-Ins and Dives. Photo courtesy the* Oklahoman.

Lamb fries are one of the specialties of the house at Cattlemen's Steakhouse. *Photo courtesy Cattlemen's Steakhouse.*

The entryway to the Coach House shortly after it opened. *Photo courtesy Chris Lower.*

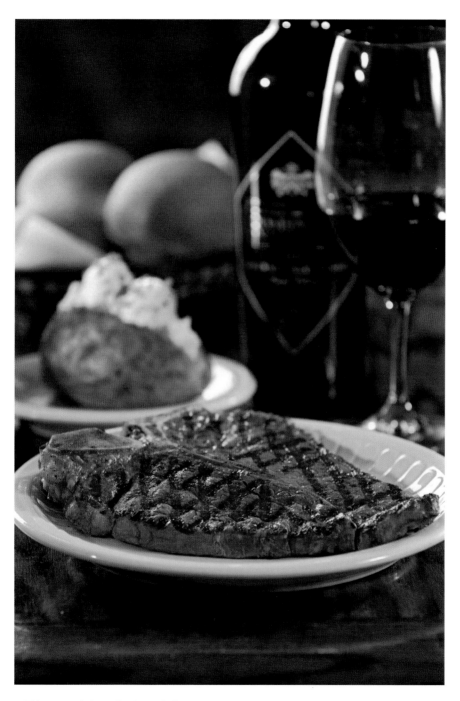

A T-bone steak from Cattlemen's Steakhouse. *Photo courtesy Cattlemen's Steakhouse.*

Chef Kurt Fleischfresser (*fourth from left*) and his apprentices Josh Valentine, Rolyn Soberanis, Kevin Ward, Mackenzie Bentley and Keith Zinke. *Photo courtesy the* Oklahoman.

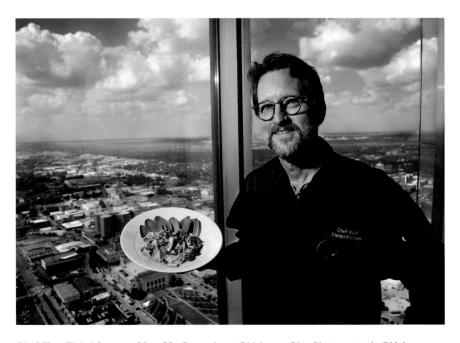

Chef Kurt Fleischfresser at Vast, fifty floors above Oklahoma City. *Photo courtesy the* Oklahoman.

Kurt Fleischfresser, David Egan, Josh Valentine and Jonathon Stranger at a cooking demonstration. *Photo by Dave Cathey.*

Justin "Nic" Nicholas earned international acclaim for his burgers at the tiny Nic's Grill. *Photo courtesy the* Oklahoman.

Chapter 13

ENDURING DINERS

THE PATIO

Loreta Eckles was making her well-known chocolate icebox pie for husband Vern long before the Patio doors first opened on October 9, 1954. Alva native and navy veteran Vern met Loreta while working as a busboy at the Greyhound station café. She worked down the street at Beverly's Grill. That led Vern to a job at Beverly's Drive-in, which ran from 1928 until a fateful drive along the Classen Traffic Circle more than twenty-five years later.

"One night I came by this place. It was so cute I fell in love with it," Eckles said. "I bought it the next morning, went home and told my wife and she wouldn't speak to me for a year."

But that didn't stop her from making herself at home in the tiny kitchen within the Donnay Building, home of the Drunken Fry today. She created the pineapple cheesecake, chocolate icebox, hot apple and cherry pies, as well as the Caesar salad taco.

The casual diner was a frequent destination for local celebrities like Governors George Nigh and Henry Bellmon and Oklahoma City University basketball coach Abe Lemons.

The menu honored longtime patrons with dishes like the "Joe Miller Burger," for the longtime photographer of the *Oklahoman*; the "Eleanor Kamber Patio K-Plate," for the owner of the long-operating gift shop Kamber's; and the chicken-fried steak plate named after land developer Clyde Riggs.

In 1976, Vern lost his chef of twenty years, Johnny Mayfield, to cancer. The loss was devastating.

"I don't see any possibility of replacing him. I know that's a defeatist attitude, but I just don't think it's possible," Eckles said at the funeral.

He sold the restaurant to longtime customers Ronnie and Gary Massad two years later. In 1980, the Massads sold the Patio to Jerry and Johnny Chism, who in turn sold it in 1988 to Kirk Grayson, managing partner of Sher-Ron Corp. Ownership was transferred to Cooking Around, Inc., which was purchased by Kemily Wallace in 1992. Wallace closed the thirty-five-seat restaurant in 2000. The space remained vacant for three years before it was replaced by Chicas Mexican Café, which offered a Patio Taco Salad. Chicas moved to Nichols Hills Plaza after a short time, opening the space to the Drunken Fry.

SHIPMAN'S

It was a blue collar, blue plate kind of joint. Nothing fancy about 'em, just good food at a very good price. A man could get a hot plate cheaper than a fast food combo.
—Randy Speegle, 1988

F.C. Shipman came to Oklahoma City in 1920 and eventually opened four Shipman's Restaurants, which were famous for their fried chicken and biscuits.

Shipman turned the business over to his daughter Virginia and his son-in-law Harlan Speegle in 1959. The Speegle family kept the restaurant going until 1988.

Randy Speegle said, "Famous people would stop by when they came through town….Gov. David Hall was a regular, coming in almost every Wednesday."

"In the 1960s, Clara Luper came in with some black dignitaries and my father served them as regular customers when that wasn't as socially acceptable as it is now," eldest son Harlan Speegle Jr. said. Before the health department ordered him to stop, Harlan Speegle would gather leftover biscuits for homeless shelters and other charitable organizations, Randy Speegle said.

"To my dad, business was about caring for the customer one at a time, all of the time. It didn't matter if it was a cup of coffee or a table of ten," Harlan Jr. said.

And what about that biscuit recipe? "I can assure you, it's in safe hands."[45]

FLORENCE'S RESTAURANT

If you are in a bind, you can depend on her, just like the sun coming up.
—Lee Cornish, 2008

Six years before Clara Luper began the crusade for equality at local restaurants, twenty-year-old Florence Kemp shrugged off the odds against a young, black female from the country opening a successful business in 1952 Oklahoma. She established Florence's Restaurant.

"When we first opened, everything I had was secondhand, including the pots and pans, and the stove," said Kemp in 2008. "I opened it on a wing and a prayer, and I've been blessed with good business ever since."

Kemp was born and raised in Boley. A couple of years after she graduated from high school, her mother moved to Oklahoma City to work as a maid. Florence followed in her mother's footsteps, but her career in domestic service only lasted about a week.

A summer trip to visit relatives in California introduced her to a whole new world, where black-owned businesses flourished and community grew. With that inspiration still fresh, Kemp opened her restaurant at 916

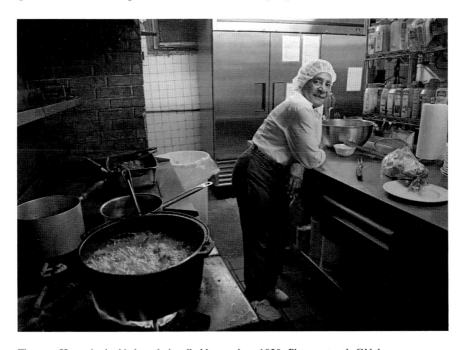

Florence Kemp in the kitchen she's called home since 1959. *Photo courtesy the* Oklahoman.

Northeast Fourth Street, serving home cooking. Seven years later, urban renewal forced her northeast to the location she's called home ever since, at Northeast Twenty-third and Fonshill.

Folks walk into Florence's, stick their heads in the kitchen to say hello, find a table and sit a spell for fellowship and communion over homemade corn muffins sopped in gravy. The only disputes are over who gets the last piece of dark meat and whether the gravy should come on the side or smothering pork chops, fried chicken or hamburger steak.

And the person in charge of the tiny kitchen today is the same person whose name is on the sign. That's how it was at Florence's Restaurant in 1952, and it hasn't changed as of 2016.

Not quite ten years ago, Kemp needed help and called her daughter Victoria, who was living in Dallas.

"So I started working to try and learn my mother's recipes," she said. "I would make pancakes, and she would say things like, 'Those are good pancakes, but they're not my pancakes.' So we kept working until I got it right."

Florence's Restaurant doesn't push the boundaries of gastronomy. It carries out the less glamorous but no-less-important task of holding the line for quality and preservation of our rich, local culinary culture. After sixty-four years, Florence's grip on that line is so strong that only the roll-call from up yonder could break it.

"I'm retirement age right now, but I'm not retiring," Kemp said. "When you retire, you don't have anything to do. I am going to keep doing this as long as I am able."

The Sit-Ins

The name Clara Luper might not resonate like Rosa Parks, but the Oklahoma City native's role in the civil rights movement is no less profound. Luper led one of the country's first sit-ins, at Katz Drug Store, eighteen months before the Greensboro action.

A history teacher at Dunjee High School in 1957, Luper became adviser to the Oklahoma City NAACP's youth council. On August 19, 1958, Luper led three other adult chaperones and fourteen members of the youth council into the drugstore, took seats at the counter and asked for Coca-Colas. Denied service, they refused to leave until closing. They

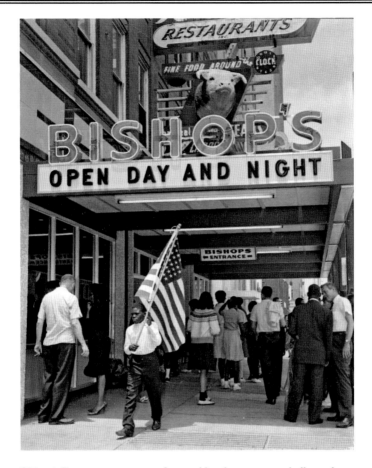

Bishop's Restaurant was one of several local restaurants challenged for refusing service to African Americans in the 1960s. *Photo courtesy Oklahoma Historical Society.*

returned on Saturday mornings for several weeks. The sit-ins received local press coverage. Eventually the Katz chain agreed to integrate lunch counters at its thirty-eight stores in Oklahoma, Missouri, Kansas and Iowa. Over the next six years, Luper and the local NAACP held sit-ins that led to the desegregation of almost every eating establishment in Oklahoma City, including the Split-T, the Anna Maude Cafeteria, O'Mealey's, Adair's and Bishop's Restaurant, as well as the Skirvin and Huckins hotels.

Luper was arrested twenty-six times at civil rights protests. Her diligence eventually repelled ignorance and racism from 1958 until antiquated

separatist laws were vanquished. Today, a street is named after her, and she is viewed as a cultural pioneer. Luper retired from teaching in 1991.[46]

CULTURES BLOSSOM, BOOMERS FINALLY BUSTED

The early 1960s saw the assassination of JFK and civil unrest in the Deep South, causing America to mature, sometimes kicking and screaming. But it also saw the outbreak of Beatlemania, which revealed the buying power of youth. Oklahoma City diners found variety in theme restaurants, the first vestiges of truly fine dining and exponential expansion of restaurants offering ethnic cuisine.

Tragedy struck the restaurant community directly when mass murderer Roger Dale Stafford killed six people in a south Oklahoma City Sirloin Stockade on July 16, 1978.

Prosperity and discovery came to a screeching halt in July 1982, when Penn Square Bank's criminal lending methods sent shockwaves through the banking world and left the local economy in an ash heap.

Perhaps no restaurant better illustrated the dance between chaos and order during this era than a place that started as a crime scene and ended up an enduring setting for celebrations and special occasions.

Chapter 14
FINE DINING TAKES SHAPE

THE HAUNTED HOUSE RESTAURANT

This place isn't haunted. It just has a haunted past.
—Marian Thibault, 2009

On June 1, 1963, seventy-four-year-old retired automobile dealer Martin Carriker was reported missing by his stepdaughter, Margaret Pearson. Two days later, Carriker was found dead in the high brush about a quarter mile from his home, a bullet from a .22-caliber rifle fired through the base of his skull.

Carriker and his wife, Clara, divorced in 1956, but she and her fifty-four-year-old divorcée daughter, Margaret, continued to live on the property not far from the old Kentucky Club. Pearson was later charged with murder, along with hired hands Ray McCoy, eighteen, and Speedy Peoples, fifty-five. But the macabre situation was only beginning. Clara was found dead of natural causes at home shortly before her daughter's trial.

Pearson, represented by renowned local defense attorney George Miskovsky, was found not guilty one week before the assassination of President John F. Kennedy. Carriker's death remains an unsolved crime to this day.

After the verdict, Pearson said, "I don't have any place to go or any friends."[47]

But Pearson's freedom was no respite. The property went into foreclosure shortly after her release. The day the sale was to be finalized, shortly before Valentine's Day 1964, a workman thought he heard water running

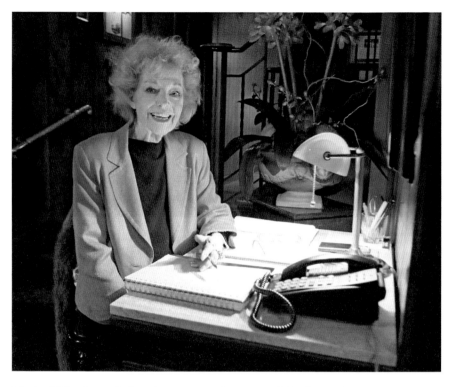

Marian Thibault was the longtime owner and operator of the Haunted House. *Photo courtesy the* Oklahoman.

inordinately in the house and went in to investigate. He found Pearson dead of an apparent drug overdose. Less than five months later, the country estate built of native stone in 1935 stood empty.

E.J. "Catfish" Davis, an oilman by trade, purchased the property at a sheriff's auction, seeking to convert it into a club. He hired Art Thibault, a young operator with whom he shared a Minnesota heritage, to run it. Thibault was manager of the original Jack Sussy's Italian Food and Steak House on North Lincoln, a place frequented by Davis and most of the prairie town's nouveau riche.

Thibault, who came to Oklahoma by way of the air force and Tinker Field, was drawn to the property because it reminded him of a restaurant on a country estate back in Minnesota. He recalled that people drove from across the state to enjoy the quiet elegance in the secluded restaurant. Thibault thought the property's notoriety would only enhance its cachet. And it didn't hurt that the nearby Braniff Estate also had a ghostly reputation. Just a mile and a half away on Northeast Sixty-third and Grand, rumor had it that a

fiendish albino popped up unexpectedly to frighten loitering teens. This, along with the three deaths on the Miramar property and the labyrinthine drive lined by gangly trees, meant that the Thibaults had a built-in draw. Thibault hired young Vidaree King to manage kitchen duties on day one—it would be the only person he ever hired for the job. King cooked for the restaurant with precision and style for forty-nine years. Former coworker Connie Lyons remembered King as the orchestra leader of the operation.

"Vi served so elegantly," said Lyons, who was hired in the early 1980s. "She timed everything just right. The Haunted House has never been a place for a quick dinner, it's always been an experience. Vi understood that and she served appropriately."

When Art Thibault died in 1994, Marian and King didn't slow down. Romantic, candlelit dinners on white tablecloths in any of the eight dining rooms of various sizes and shapes carry forth. The restaurant still specializes in steaks, seafood and ambience. The Haunted House hosted Bob Hope, Liberace, Neil Young, Sarah Ferguson, Paul Harvey, Lauren Bacall, Dan Blocker, Mickey Mantle and George W. Bush. But none of those celebrities or dignitaries would prove as important to the restaurant as a young Iowa farm boy who happened into the dining room in the early 1980s.

His name was Patrick Boylan, a freshman at the University of Oklahoma who used the elegant dining room to close potential clients for his fledgling event-planning business. Boylan's business took root and grew

A portrait of Marian Thibault overlooks the dining room at J. Bruner's at the Haunted House. *Photo courtesy the* Oklahoman.

into an international operation, generating enough capital for the young entrepreneur to buy J. Bruner's Restaurant in Osage Beach, Missouri.

In 2001, the heirs of Catfish Davis agreed to sell the property to Marian Thibault. Vidaree King passed away at the age of eighty-four in 2012. Thibault worked her way out of Nazi Germany as a young lady to become a restaurateur for five decades. She worked until she was eighty-nine, finally succumbing to cancer in May 2015. Fifty-one years after it opened, the Haunted House went dark in April 2015. The restaurant went to auction shortly after.

Re-enter Boylan, owner of PDC Productions. He bought the property at auction and reopened it as J. Bruner's at the Haunted House on July 4, 2015. Looming over the bar at J. Bruner's at the Haunted House today is a portrait of Marian Thibault, ever the hostess in her elegant haunt.

THE CELLAR RESTAURANT AT HIGHTOWER

Frank Hightower didn't see any sense in doing things unless it was going to be done perfectly.
—Dannie Bea Hightower, 2010

Between his birth in 1922 and death on October 10, 2000, Frank Hightower raised a family, expanded the family fortune and helped evolve the sleepy prairie town he loved into a cosmopolitan city. He opened the Cellar Restaurant in his Hightower Building around 1958 but converted it into the city's first true fine-dining restaurant in 1964. The Cellar signaled a shift in local dining, inspiring young chefs until it closed in 1984.

"Frank Hightower had an obsession with fine food," Dannie Bea told the author in 2010. "He flew to New York City to take cooking classes."

The teacher of those classes was James A. Beard, America's preeminent gourmet and instructor of French cuisine. Beard agreed to help Hightower install an opulent new design for the Cellar, which previously operated as a tearoom. Anna Maude Smith's favorite interior designer, Warren Ramsey, was the only man Hightower considered to design his world-class restaurant's interior.

Beard's job was to hire a chef, and the first person he called was a young chef who had worked in a restaurant he consulted for called the Mermaid Tavern in Stratford, Connecticut. His name was John

The opulent dining room of the Cellar at Hightower. *Photo courtesy John Bennett.*

Bennett, an Oklahoma native recently returned from a trip across France with Culinary Institute of America classmate Robert Dickson. They had traveled from restaurant to restaurant, carrying a letter of recommendation written in French by Julia Child. The whirlwind trip had been educational, but when Beard called, Bennett was back working at the Mermaid Tavern. When he came home for the holidays in 1963, he went to Oklahoma City to meet with Hightower.

"Mr. Hightower had exquisite taste and had traveled all over," Bennett said. "He'd visited all the finest restaurants and was determined to open one downtown."

Bennett accepted and within weeks was helping design the expanded kitchen at the Cellar and working with Beard on the menu. When the new dining room opened to the public in early 1964, all it did was change dining in Oklahoma City forever.

Diners entered via stairs or elevator into a foyer with black-and-white marble floors leading to an eighteenth-century wooden table. After check-in, they entered a luxurious dining room lit by custom-made wall sconces,

Chef John Bennett with James Beard in 1974. *Photo courtesy John Bennett.*

crystal chandeliers and ornate tabletop candelabras. The red carpet with golden rings matched the custom-upholstered wooden chairs. The linen-covered tables were appointed perfectly with damask napkins, silver and dinnerware stamped with the Hightower family crest.

"He brought opulence here when we had none," Dannie Bea said of her husband.

"We even had a fish knife," Bennett said. "He might've been the only person in the city to know what a fish knife was, but he insisted we have them."

Bennett was chef, then director. He brought in Dickson as executive chef. The menu featured fresh fish daily and dishes such as shrimp de jonghe, croque monsieur, shrimp remoulade in avocado, cannelloni au gratin,

carbonnade of beef a la Deutsch, escargots a la bourguignonne, crepe aux duxelles, crabmeat ravigote, celery Victor and New England clam chowder.

Meals ended with a rolling dessert cart featuring Mama Bennett's four-layer cake, trifle chantilly, oeufs a la neige and legendary chocolate mousse. Chicken salad and Reuben sandwiches were favorites of the lunch menu, Bennett said. Desserts were prepared by Clara "Fergie" Ferguson for many years.

The Cellar earned four stars from the *Mobil Travel Guide* in 1968, making it the state's only restaurant at the time to reach that plateau. Simone Beck, coauthor of *Mastering the Art of French Cooking* with Julia Child, conducted classes at the Cellar.

By 1984, Frank Hightower's Cellar restaurant had achieved its owner's goals, so he felt comfortable closing it. The space was briefly used by the Woods restaurant, previously in the Sieber Hotel, but it closed within a year.

"People were very upset about it," Dannie Bea said. "But it was just a lot of work, and Mr. Hightower felt like he'd accomplished what he set out to do."

His other goal was to help his hometown gain culinary notoriety.

"We met Julia Child in Venice once," Dannie Bea said. "He knelt before her and kissed her hand. Then he said, 'Miss Child, you've brought so much joy to my life.' She thanked him and said, 'That's very kind, Frank. Thank you….I've heard about your wonderful restaurant in Oklahoma City.'"

CHEF JOHN BENNETT

When James Beard was ready to hire a chef for the Cellar, he chose the only chef from Oklahoma he knew. John Bennett was born in Healdton and raised in various spots in southern Oklahoman before graduating from Norman High School. Bennett spent a year at OU, where the only education that stuck came from afternoons spent in the Bizzell Library paging through the gourmet magazines.

"Those magazines were the best education I got in my short time at OU."

That's where he also read about the Culinary Institute of America, which had opened in 1947 as a vocational training school for returning World War II veterans in New Haven, Connecticut. Bennett attended the CIA from 1962 to '63 and worked the entremetier for chef Albert Stockli at the nearby Mermaid Tavern in Stratford. It so happened that Beard owned a stake in the Mermaid Tavern. A lifelong friendship ensued.

A photo in John Bennett's 1963 yearbook from the Culinary Institute of America doesn't bother to identify Julia and Paul Child, as her *Mastering the Art of French Cooking* was still months from publication. *Photo courtesy John Bennett.*

"Once he mentioned he did cooking classes in Oklahoma City. My response was, 'Why!?! Nobody there knows how to eat,'" Bennett said.

He invited Beard on a tour of the CIA in 1961. Beard accepted but asked if he might bring a couple of guests along. Bennett agreed. The guests were a married couple who had only recently moved back to the United States from France, where the husband worked for the U.S. State Department. While there, his wife attended the famed Le Cordon Bleu cooking school and used the knowledge to cowrite a tome on French cooking in English. Beard introduced them as Paul and Julia Child. In the 1961 yearbook of the Culinary Institute of America is a photograph of the group—the Childs are unidentified.

That spring, Bennett and Dickson visited the Childs at their home in Cambridge, Massachusetts, where they cooked for them using galley copies of the aforementioned tome due for publication that August. The book was *Mastering the Art of French Cooking, Vol. 1.*

Frank Hightower's commitment to fine dining and John Bennett's skills planted the seed for Oklahoma City's culinary identity today. But Bennett's success was only partially about cooking.

"Anything worth doing is worth over-doing," Bennett often says. "My dad always told me, 'You've got to sell the sizzle.'"

Bennett took his father's advice to heart in preparation for an event at the Biltmore Hotel. He knew that many of the country's circuses wintered in Hugo, not far from Healdton, where he was born. He rented an elephant from one and dressed as a genie to make a grand entrance.

"The elephant squatted down to its knees so I could get on," Bennett said. "When he straightened up, my legs shot straight up in the air. It was like doing the splits!"

Bennett also had a knack for finding local talent. Leo Smith, who went on to open the iconic Leo's Barbecue, was a waiter at the Cellar. Chefs Larry Brannon and John Vernon worked under Bennett. Brannon would help his mother turn Alberta's Tea Room into a local institution. Vernon would later open Chez Vernon.

"He even served our chocolate mousse at Chez Vernon," Bennett laughed. "It was a wonderful restaurant, and John was a very nice man."

Perhaps Bennett's greatest influence occurred when a twelve-year-old boy dressed in a suit, who had taken the bus downtown for lunch, confidently walked into the Hightower Building, descended the stairs, approached the host and asked for a table for one. His name was Rick Bayless, and by the time he'd finished his steak Diane, duchess potatoes gratinee and chocolate mousse, he knew he wanted to be a chef.

"The chocolate mousse experience I will never forget because they gave me a silver bowl and I could have as much as I wanted," Bayless recalled in 2013. "I didn't even breathe as the server went in [to the bowl] and hoisted out these spoonfuls for me."

Bayless would tell Bennett later that year:

> *That experience kind of changed my life. I'd been watching Julia Child and, even at that age, I'd bought that first volume of* Mastering the Art of French Cooking *and I'd started cooking through it. I knew [the Cellar] was the place I could go and have that fine dining experience. And after that chocolate mousse I thought, "This is the world I want to live in."*
>
> *Thank you very much for participating in who I am today.*

Bennett left the Cellar in 1969 and worked briefly at the Skirvin Hotel and Christopher's before moving to San Francisco, where he cooked at legendary Jack's Restaurant. He would return in 1975 to open Grand Boulevard Café, which had a short but spectacular life.

When John Bennett returned from San Francisco, he opened Grand Boulevard Restaurant in the space long since occupied by Flip's Wine Bar and Trattoria. The restaurant became a popular stop for traveling entertainers like Tab Hunter and Ginger Rogers.

The Grand Boulevard was open for only five years, but it made an impression on a young Chris Lower, who was asked by a girl who worked at the restaurant if he could cover her shift one night. Lower ended up working at the Grand Boulevard off and on during summers between semesters of college and became a favorite of Bennett's.

"He used to go in his office after service with his dog, Mr. Beau, and tell me to make him something to eat," Lower said. "He would never tell me what he wanted, he would just say, 'Make me something.'"

It was Lower's first restaurant job, which would end up being the only kind of job Lower ever had. Today, he continues to be one of Oklahoma City's most successful and important restaurateurs.

As for the Grand Boulevard, its short, dazzling life came to an end in 1979. Bennett left in 1978, shortly after one of the owners tersely addressed the staff, which served little more than setup to a clever rejoinder.

"You all have got to stop taking things from the restaurant," said Jeanne O'Neill, who was a partner along with her husband, Mike O'Neill.

Bennett remembers Julio Sanchez assuring, "But Mrs. O'Neill, there's nothing left to steal."

Greg Gawey of Jamil's purchased the Grand Boulevard in 1978; it closed for good in 1979.

Bennett also wrote a monthly column called "In a Chef's Manner" for the *Daily Oklahoman* and would later regularly appear on *PM Magazine*.

Jacques Orenstein

French cuisine came to Oklahoma City in 1963, when Jacques Orenstein abandoned a sales career specializing in women's pret-a-porter to buy a restaurant at Northwest Fiftieth and Shartel.

In 1965, he called it "a tearoom for little old ladies with hats." The next year he converted it into Jacques' Internationale, but the city wasn't quite ready for it.

"The fare in Oklahoma City in 1963 was fried chicken, chicken-fried steak and then came steak. That was it."

Born in West Virginia, Orenstein grew up in Cleveland. He moved to Oklahoma City in 1952 after following his family to New Orleans, which he pointed to as the inspiration for his culinary endeavors.

"My father's family was from Vienna and were both French and Austrian. My mother's family was from Germany and Hungary. So I grew up with good food. We weren't wealthy or anything like that, but it was just they all cooked well and I learned something about good food when I was young."

The same year he opened Jacques' Internationale, he was approached about doing a weekly cooking segment on WKY-TV's *Dannysday* program. He accepted and continued until 1971.

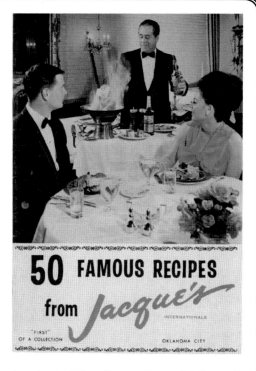

A recipe book from Jacques Orenstein's Jacques' Internationale. *Courtesy Jeanette Elliott.*

"We were really scratching because Oklahoma City wasn't ready for us yet," Orenstein said. "You couldn't buy that kind of publicity."

Orenstein had no formal culinary training, but his restaurant, which closed in 1971, spawned a long career that included Jacques' Sign of the Ram at the Sheraton Inn near Will Rogers World Airport (1968–74) and the French Revolution on Northwest Expressway (1974–76). Orenstein and his son Jon opened the Creative Cookery school in 1976 and operated it until 1985. He died at the age of eighty-one in 2000.

CHRISTOPHER'S

In 1965, J.C. and Ruby Wood began opening their home in a wooded area near what is now Will Rogers Park to diners. After the Woods retired, sons Larry and Jerry carried on the tradition and built it into one of the city's most elegant restaurants, overlooking a small pond and large pasture populated by horses.

When Interstate 44 was built, it eliminated two acres from the property and signaled the beginning of the end.

"It ruined the aesthetics of the property," Larry Wood said in 1986.

But the bullet that put Christopher's down was self-inflicted. When liquor-by-the-drink passed in 1985, the Woods opted not to apply for the proper licenses, joining Eddy's Steakhouse as holdouts. Eddy's changed course and saved the business a few years later, but Christopher's closed within a year.

For the previous two decades, the Coventry Lounge had been a common site for after-parties and receptions for touring theater stars like Lena Horne and the cast of *Annie*. The restaurant was a common stop for special occasions, lavish parties and unmatched service.

"Nobody could work a dining room like Larry Wood," Metro Wine Bar and Bistro owner Chris Lower told me. "In his prime, I'd never seen anyone like him, and frankly never have since. He was a master."

Jerry Wood said the restaurant business dropped off as much as 75 percent after ceasing liquor sales. Christopher's closed in the summer of 1986.

JAMIL'S STEAKHOUSE

There's always a hello and a handshake welcoming me as soon as I walk through that door no matter how long it's been since my last visit. And no matter how long it's been since my last visit, there are always the same faces there to welcome me back. Jamil's is truly a special establishment and it's the people who work there that make it special.
—Jeremy Hargis, 2015

The Elias clan came to Oklahoma by way of Belize around World War II and, as many other Lebanese expats did, settled in Bristow. Jim opened his first restaurant in Bristow. He moved to Tulsa in 1944 to open Jimmy's Hollywood Club on Eleventh Street. Two years later, Elias decided to use his Lebanese

name and serve the food of his homeland along with favorites from his adopted country at Jamil's Steakhouse, which was originally on Harvard Avenue. In 1957, he moved to East Fifty-first Street. The menu had plenty of steaks and chops but also offered Lebanese appetizers, including tabbouleh, hummus, flat bread, relish and cabbage rolls mixed with barbecue ribs, smoked bologna and sausage. Jamil's was a hit, so in 1964, Elias purchased a property in Oklahoma City's most vibrant entertainment district, just north of the Capitol.

"Lincoln Boulevard used to be like the Las Vegas strip," owner Greg Gawey said. "Back in the '60s, this place was hoppin'."[48]

The new Jamil's was built as a luxury home in the 1930s before becoming a club in the 1940s and '50s, where alcohol consumption, gambling and women trading on their wiles were always present.

When Jamil's son Tyrone took over the operation, he expanded Jamil's to Dallas and Houston. Greg Gawey came to work for his uncle Jim in 1969 and took ownership in 1976, when the Eliases began to pare down. Gawey also opened the Brown Bag Deli and the Smokehouse in Nichols Hills and purchased the Grand Boulevard Café in 1978, around the time his uncle Jim died. The Brown Bag and Jamil's remain in operation.

Oklahoma representatives and senators munching smoked bologna sandwiches at Jamil's during legislative session is still a common sight. For dinner, Jamil's serves top-choice steaks and traditional Lebanese hors d'oeuvres, just like its namesake did in the beginning.

"Our motto is 'Slow down,'" Gawey said. "Come in, sit down with us, slow down the pace. Take your time, have some drinks, eat a little, talk with your friends and eat some more."

The elegant, low-lit dining room is splashed in deep red and mahogany with walls featuring pictures of some of the restaurant's famous patrons from bygone days.

Longtime employee Darryl Ladd said Jamil's was more than a job or a place to work after school or during the summers for his family. "Working at Jamil's was a genuine education that couldn't be gotten at any of the other places we worked while growing up," Ladd said. "All six of the Ladd children worked at Jamil's while in high school, after high school graduation, in college, and even after college graduation."

Ladd said he learned the business of business from Gawey, who demonstrated firsthand how to deliver and exceed customer expectations and how that led to repeat visits.

"One more thing," Ladd said. "After almost forty years, we still have cravings for tabbouleh, cabbage rolls, hummus, and of course those hand-cut steaks."

Eddy's

As someone who has eaten there for 30 years almost, the quality has always been the same. You always knew it was going to be perfect. We never, ever had a bad meal there.
—Becky Worstine, 2007

Eddy Elias owned a filling station and appliance store in Bristow when his brother Jimmy opened Jamil's Steakhouse in Tulsa. Seeing his brother's success, Eddy opened Eddy's in Tulsa, serving the same Lebanese hors d'oeuvres and steak.

Eddy's son Chris opened Eddy's Steakhouse in Oklahoma City in a small house at 4227 North Meridian in the summer of 1967. Capacity was less than fifty. By the time Eddy's closed its doors in 2007, it had grown to 8,800 square feet and 450 seats.

When it finally became legal to sell liquor by the drink in 1985, Eddy's was one of two restaurants that resisted the temptation to apply for the license on moral grounds. However, two years later the Eliases were forced to reopen the bar or close. The move proved fruitful, as Eddy's stayed open another twenty-two years.

Junior's

Junior Simon's dream came true in September 1973, when he and partners Carl Swan and J.W.W. Whitney opened Junior's Supper Club in the basement of the Oil Center on Northwest Expressway.

Simon had starred on the offensive line at Central High School while growing up with his siblings supported by the family pool hall. After high school, he worked in hospitality in Oklahoma City and Tulsa, saving his money along the way until he found Swan and Whitney.

Managing the Habana Club and co-owning the Hilton Hotel in Tulsa helped Simon develop a knack for remembering people's names after meeting them for the first time. He was a well-known bartender at the deVille Club across from Penn Square before finding his basement spot a few blocks west on what everyone called Northwest Highway. Junior's boasted an opulent dining room with red upholstery, white linens, burgundy carpet, crystal chandeliers and a sunken piano bar for

the nouveau riche oilmen almost a decade before the Penn Square Bank shook the foundation of American banking.

With hand-cut steaks, lobster from New Zealand, Caesar salads made tableside and signature brandy ice from chef Aaron Cochran Jr., the exclusive club became "The Oilman's Oasis." Simon didn't bother with menus; servers recited the fare from memory.

"If someone asked for a menu to look at prices, Junior would tell them they were in the wrong place," said longtime regular and Pfizer Pharmaceutical executive Jim Shumsky.

With liquor-by-the-drink still a dozen years away, liquor-by-the-wink service was offered in full at the private bottle club for the city's growing wealthy class. The club opened with more than five hundred members. New members could apply only by recommendation of an existing member. House accounts were more common than not.

Originally from New York City, Shumsky and his wife, Martha, got their invite to join Junior's in December 1973. "As soon as I walked in the place, I fell in love with it," Shumsky said. "I became a regular that night."

Junior's was intimately related to the Penn Square Bank scandal. Deals written on Junior's cocktail napkins were entered into evidence during the ensuing court, according to the book *Funny Money* by Mark Singer.

"Junior's became the sanctum sanctorum of new oilie-ism," he wrote.

Junior's claims responsibility for bringing tableside Caesar salad to town. Michael Sills was working at Junior's in those days, and when he eventually left to open Michael's Grill in Nichols Hills in 1996, he brought the tableside Caesar with him.

Throughout the 1970s, Junior's became not only the place to be seen but also the place to work.

"I went to work at the Skirvin in the late Seventies, but I wanted to go to work at Junior's," said Cheryl Steckler, who eventually got a job with Simon in 1980. Steckler, whose parents, Bob and Lola, owned the 313 Coffee Shop, the Katy Grill and the Éclair, said that in those days, "I can guarantee you some girls were making six figures."

She said by the time she got to Junior's, he had mellowed. "The girls who worked there for a long time said he had been a terror in the early days," she said. "But by the time I got there he was just the sweetest man."

After the Penn Square fiasco, sales slipped at Junior's and all over the city when the economy went bust, but Simon doubled-down with a $150,000 overhaul of the restaurant in 1982. He died on November 2, 1984, from pancreatic cancer, just weeks away from his sixtieth birthday. Junior's wife,

Genell, and her brothers-in-law Otto Rahill and Kaye Simon partnered with Cochran to keep the place going, but it was always a struggle after Junior died—thanks in no small part to the wreck Penn Square had made of the economy. They would carry on until 2004, when they were able to convince Jim Shumsky to put off retirement and become a restaurateur.

Buoyed by support from longtime staffers like Sue Roberts, Steve Farrokhin and Junior's baby sister Kathy Eckstein, Shumsky's only significant change was encasing the bar in glass and outfitting it with a twenty-six-ton air-purifying unit to pull the smoke out of the bar when smoking was outlawed in 2003. Otherwise, it was business as usual.

"Genell agreed to sell it to me on the condition I wouldn't change anything, and I would honor her husband," Shumsky said. "She never needed to ask me to do that. The way I see it, this is Junior Simon's place. I'm just watching it for him."

Chapter 15
VARIETY IS THE SPICE OF LIFE

Appetite for exotic flavors intensified through the years, and restaurant operators were quick to exploit the trend. Though Luis Alvarado would retire and his El Charrito would vanish, his influence is still felt today. An influx of Vietnamese refugees switched the direction of Asian food, barbecue enjoyed renewed interest and Italian cuisine would come from new sources.

But a pair of entrepreneurial-minded Oklahoma State graduates would develop a system to become all things to all potential diners. They opened a variety of restaurants, many of which revolved around specific themes.

VAL-GENE RESTAURANTS

Gene Smelser and Jim Vallion began their restaurant careers shortly after World War II, but their influence on Oklahoma City dining history hit its stride in the mid-1960s.

Gene Smelser grew up in Oklahoma City, graduated from Classen High school in 1937 and attended Oklahoma A&M. There, he continued his basketball career under legendary coach Gene Iba and earned all-conference honors in 1939 (honorable mention), 1940 (second team) and 1941 (first team) in the Missouri Valley Conference.

Smelser joined the U.S Navy shortly after graduation and was commissioned in Pearl Harbor. He rose to lieutenant and coached basketball

while serving as operations officer in charge of all base commissaries and stores. Smelser returned to Stillwater and worked as an assistant to Iba, coaching the freshman team.

Jim Vallion grew up in the tiny town of Panama in LeFlore County, the oldest of seven kids. His passion for 4-H Club led to a scholarship to Oklahoma A&M. "When I got to college it was the first time I ever had a bed of my own," Vallion recalled. "Once I had my own bed, I swore I'd never go home, and I didn't."

Vallion took a job in food services, working the register at the dining hall where Smelser led his freshman team for meals. A lifetime friendship formed. Smelser owned a stake in a local restaurant and hired Vallion to work for him. Not long after, they opened Stillwater's first drive-in restaurant, Town House Restaurant. Soon Smelser and Vallion added the Country House, Villa Drive-in and Louie's Club, a beer hall.

"Gene couldn't keep his stake in Louie's because it was a beer hall." State law at the time wouldn't allow state employees to own any business involved in the sale of alcohol.

In 1959, Vallion and Smelser took their show to Oklahoma City and changed the landscape with Val-Gene Associates, a progressive restaurant group. They were drawn to the city by Ben Wileman, a developer working on an ambitious open-air, regional shopping center along the U.S. 66 bypass called the Belleview Shopping Center because of its proximity to the Belle Isle power plant to the east. Wileman assured Vallion and Smelser that Belleview would be the largest shopping center between Chicago, Dallas and Denver. While they waited, they operated properties in the Cameron Building/Classen Building.

In 1960, Wileman leased substantial square footage to Vallion and Smelser to operate Valgene's Cafeteria, the Red Eagle Room, the Coq d'Or and the Silver Palm Room. They also opened a cafeteria in Shepherd Mall.

Smelser's nephew John recalled:

One time, Buddy Rodgers brought noted New York designer Bill Blass here for a Balliet's fashion show in the Silver Palm Room. Asked at the luncheon if he was doing all right, Blass said, "I'd be doing fine if I had a martini." I was able to fulfill that need right next door at the Coq d'Or.

Gene always came through in times of need. He loved modeling in the men's fashion shows presented each year by the Fashion Group International. The late John Ooley always dressed Gene for these shows. Gene's favorite time was when Mr. Ooley's store outfitted him in a full-length mink coat and matching mink cowboy hat.

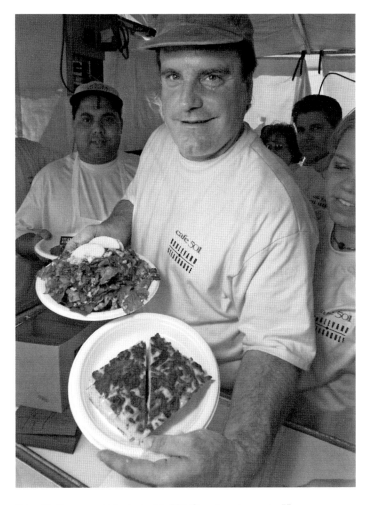

Peter Holloway got his start with Val-Gene's restaurants. He now owns Boulevard Steakhouse in Edmond, two Café 501 locations, Park House Catering and Ice House in the Myriad Gardens. At rear left is chef Nordeen Bennai, who started at Sleepy Hollow and now works at Zorba's Mediterranean Cuisine. *Photo courtesy Oklahoma Historical Society.*

The Vallion and Smelser partnership extended over five decades. They split their operation into three divisions for a parade of more than thirty concepts. Some were original, others were national franchises: Sidewalk Café, the Hungry Peddler, Herman's Seafood, Harry Bear's, J. Isaac Grundy's, Chicago's, Dakota's, Platter's, Shorty Smalls, Across the Street, Pelican Pete's, the Eagle's Nest, El Zocalo, Texanna Red's, Pepperoni Grill, Chequers, Triple's, City Café, Reuben Rugby's, J.B. Nimble's Ice Cream

Parlor and Yukon Mining Co. in Yukon. Vallion worked the front, Smelser the kitchen.

"It wasn't a surprise to see Gene Smelser in the kitchen chopping onions or washing dishes in an Armani suit and Gucci shoes," longtime partner Peter Holloway recalled.

The Hungry Peddler was the original fast-casual restaurant in Oklahoma City, said Peter Holloway, who started as a waiter there when it opened in 1973 and eventually became a partner. He now owns two Café 501 restaurants—one in Oklahoma City, one in Edmond—Boulevard Steakhouse in Edmond and Park House and Ice House in the Myriad Gardens. He also owned Classen Grill for a time.

Before the Hungry Peddler, local diners looking for a full-service experience had cafeterias or fine dining. The Hungry Peddler blended both, with its large salad bar and live entertainment on weekends.

Val-Gene's offerings ran the gamut, but none soared higher than the Eagle's Nest. Replacing the old Chandelle Club atop United Founders Tower in 1979, the revolving restaurant featured a menu by chef Chad Scothorn and later Martin David Van Stolk. The Eagle's Nest offered an alternative to subterranean fine dining at the Cellar with the loftiest perch from which to dine at the time.

"We have a lot of great memories of the Eagle's Nest," Holloway said. "I wish those guys the best."

The good times lasted until 1996, when the restaurant was bought by a new group. Current Opus Prime Steakhouse owner Bill Wilson installed Nikz at the Top.

Val-Gene's was humming along, riding the crest of oil money and expanding almost as fast as contractors could complete projects, when Oklahoma City's economy collapsed thanks to the oil bust and the ensuing failure of the Penn Square Bank. The partnership continued forward with plans, but soon the floundering economy shrank volume around the city.

HAL SMITH

If Jim Vallion and Gene Smelser showed the promise of a restaurant group's potential, an Ardmore native turned it into an art form. Hal Smith was a law student at the University of Oklahoma doing his undergraduate work in the late 1960s when he took a job at Across the Street on Campus Corner,

where each table had a hotline to call in orders. Smith opened Crosstimbers, a steakhouse located in a Spanish villa, on the east side of Norman in 1970.

One of his cooks was Hank Kraft, whom Smith had known since 1964. "Hal always had the charisma of bringing people together," Kraft said in a 2000 interview with the *Oklahoman*. "You could tell that he was a born leader, and he always had a positive attitude."

An out-of-town customer complimented Smith on the marinated steak at Crosstimbers that first year. His name was Norman Brinker, founder of Steak & Ale. "He gave me his card, told me to give him a call if I wanted to try something different," Smith said.

After a few more years at Crosstimbers, he called Brinker. Between 1973 and 1980, Smith moved his family to eight cities in four states. By 1979, he was an area director, overseeing ninety locations. Smith was named president of Steak & Ale Restaurant Corporation, a $400 million company, at age thirty-three. Five years later, it was a $700 million company. When Brinker purchased Chili's in 1984, Smith became the new chief executive officer of Steak & Ale. But Brinker eventually lured Smith away to become president of Chili's.

After that, Smith became chief executive officer of Chi-Chi's, expanding profits from $18 million to $38 million in two years. When Jack in the Box bought the company, the stock windfall allowed Smith to come home. In 1992, he founded Hal Smith Restaurant Group. The first addition was Charleston's, which Kraft had opened on his own six years before. The two have been partners since. Exclusive franchising rights for Outback Steakhouses in five states built an even bigger war chest. By the time Smith and Kraft opened RedRock Canyon Grille on a wooded patch overlooking Lake Hefner, the Hal Smith Restaurant Group had expanded Charleston's, sold its Outback stores back to the parent company and dominated the Ed Noble Parkway in Norman.

RedRock, an upscale Southwest restaurant, became the first top-to-bottom concept they created, leading to the openings of Mahogany, Mama Roja, the Hefner Grill, a reboot of Hollie's as a full-service restaurant in Moore, the Bob Stoops idea Louie's Bar and Grill, Toby Keith's I Love This Bar & Grill, Upper Crust Wood-Fired Pizza, the Garage Burgers and Grill and KD's with Kevin Durant.

The group still operates Krispy Kreme and purchased and expanded the Ted's Cafe Escondido concept several years ago. In the late 1990s, Smith brought On the Border to the metro and helped legendary OU football coach Barry Switzer open the ambitious, but doomed, Cabo del Sol. This brought home chef Kamala Gamble, who'd been working at Rick Bayless's Frontera Grill and Topolobampo restaurants in Chicago.

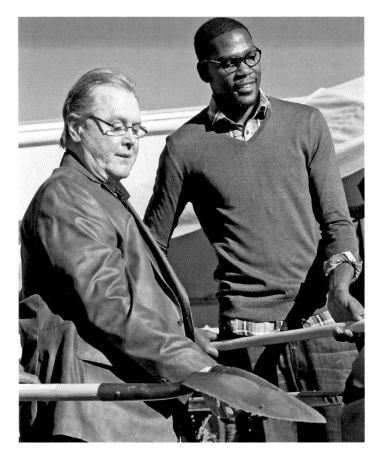

Hal Smith *(left)* and Oklahoma City Thunder star Kevin Durant partnered to open KD's Southern Kitchen in 2014. *Photo courtesy the* Oklahoman.

Smith, Kraft and their partners now boast original concepts from Arizona to Florida and as far north as Omaha, Nebraska.

THE GREAT AMERICAN RAILROAD CO.

In the 1970s, practically every theme around which a restaurant could be built was exhausted. The Great American Railroad Co., which opened in 1973 in a building erected to look like a rail yard, was a prime example. Jim Hodges was a recent graduate of Oklahoma State's School of Hotel and Restaurant Administration when he opened the railroad-themed

concept, which also included the Loose Caboose Club, at 3000 West Britton Road. Like so many of the theme restaurants of the day, it drew a lot of early interest but proved expensive to maintain. In 1982, the railroad garb was swapped for adobe, serapes and sombreros, and the establishment became J.C. Garcia's (Joe C. Garcia's out of Fort Worth) before closing and reopening as the fifth Nino's Mexican Restaurant.

The first of the Great American's two greatest contributions was seeding the grounds at 3000 West Britton Road for restaurant operation. After Nino's left, it became Good Eats, then Tulsa's Bodean Restaurant and Avalon Seafood Market. Since 1999, it's been home to the Ranch Steakhouse, one of the city's most celebrated prime steakhouses.

The other contribution was inspiring a teenager from Yukon.

"Thirty-five years ago, I was 19 and I had a great meal at The Great American Railroad. It was a grilled steak and huge shrimp grilled in-shell, [and] that was as fancy as I would eat back then. Shortly after that, I started on the path to be a chef myself," Kurt Fleischfresser told Devon Green in a 2014 interview for the *Oklahoma Gazette*.

Jim Hodges went into restaurant equipment and has owned and operated Hodges Restaurant Supply for many years.

MOLLY MURPHY'S

Perhaps the splashiest theme concept was Molly Murphy's House of Fine Repute. Bob and Jeffiee Tayar spent a good portion of their professional careers borrowing others' ideas and producing potential cash cows.

Bob's family had been in the grocery business, but he wanted to be a nightclub owner. In 1962, he opened the Sewanee Club while Jeffiee worked at Braniff International Airways. When fire closed the club, the Tayars opened Bonaparte's Drive-In in Bethany.

They opened Bonaparte's Charcoaler in Shepherd Mall and another in Texas, but neither stuck as drive-ins began to fall out of fashion.

Their next inspiration was a pair of theme restaurants they'd visited in Texas: Bobby McGee's Conglomeration in Dallas and the Magic Time Machine in San Antonio. The Tayars opened Molly Murphy's House of Fine Repute at 1100 South Meridian in 1976.

Playboy described Molly Murphy's as "a Russian Orthodox Church that mated with a ranch house." It included a toilet filled with flowers at the

entrance, upside-down flowerpots hanging from the ceiling, urinals filled with ice and a cherry red Jaguar XKE salad car in the middle of the restaurant. Waiters and waitresses dressed in character costumes entertained with rehearsed inane bits.

The beginning of the end of Bob Tayar's career in Oklahoma came when the local NBC affiliate accused him of assaulting a reporter and videographer and then videotaped his arrest when police arrived. Tayar filed and won a lawsuit against the station. But the bad publicity and the failed Mexican concept TaMolly's tapped out the Tayars in 1996. Bob died in 2004. In 2007, Jeffiee wrote *Whatever Happened to Molly Murphy's House of Fine Repute?*

DER DUTCHMAN

Adair, Inc. introduced Fort Worth seafood legend Bill Martin's Zuider Zee franchise to Oklahoma City in February 1967.

The grand building with the Dutch mill façade had two dining rooms, one of them an oyster bar with an open shucking area, a rotating lobster tank for customers to pick their own live lobsters and an indoor waterfall.

Martin sold the franchise to Ward Foods in 1968. In 1970, Adair changed the name to Der Dutchman and grew the concept across the metro over the next twenty years, serving lobster thermidor, frog's legs, shrimp stuffed with crab, oysters Rockefeller and Bienville, Dungeness crab and an array of fillets offered paneed or deep-fried. Despite almost constant scrutiny by the Alcohol and Beverage Commission before liquor-by-the-drink was passed in 1985, Der Dutchman expanded across the metro. Key among its operators was Kim McClendon, who was general manager of the original store in the late 1970s and early 1980s and became a partner in dozens of local restaurants over the years. Der Dutchman closed its last restaurant in the mid-1990s.

Chapter 16

BURGERS AND SANDWICHES

When Kaiser's opened, it served hamburgers under the category of sandwiches, along with a variety of ingredients stuffed between bread slices. In time, burgers became the centerpiece of specialty restaurants and drive-ins, while sandwiches were served in sub shops and delis.

Local drive-in burger joints thinned as the 1970s began, but those that remained endured and grew—in some cases exponentially. Others evolved from drive-ins to concepts ripe for franchising.

America's best-known drive-in came to Oklahoma City from rural Oklahoma and called it home. Before Watergate, a new burger joint with a familiar menu began a love affair with Oklahoma City that's as strong today as it was when it opened.

JOHNNIE'S CHARCOAL BROILER

I'd ride the bus home, and then I'd go to work. I worked, my brother worked, my mom and dad worked—we were a family operation. I grew up in Johnnie's.
—Rick Haynes, 2015

David Nathaniel Haynes left home in southeastern Oklahoma at a young age, leaving behind his father's way of life and the name given to him.

"The true story is my father left home at 15 years old and moved to California," David Haynes said. "When he got out there, he just started going by Johnnie—and it stuck."

He was born in the spring of 1929 to John and Molly Haynes. The family moved to Poteau, where John worked in the coal mine. Young David wasn't interested in his father's footsteps and headed west in the mid-1940s. Once in California, he started working in drive-ins and restaurants using his father's name.

The new Johnnie Haynes enlisted in the U.S. Army and spent three years in Germany as a cook before returning home to Oklahoma City for good in 1950. Haynes left the army with cooking skills, which earned him an eighteen-year stint running Vince Stephens's Split-T.

In 1971, Johnnie's son, David Haynes, was a senior in high school and one of the first managers of Johnnie's Charcoal Broiler on the corner of Military Avenue and Britton Road.

His father had recently taken over the previous home of Potter's Drive-in. Rick Haynes was thirteen when the twelve-booth, sixteen-speaker drive-in with inside seating for forty-eight opened.

By the time Johnnie Haynes passed away in 2000, David and Rick had been running the family business a while. "After Dad retired he was the one calling me to come play golf with him, and I was the one having to tell him no," Rick Haynes recalled. "He really enjoyed himself after he retired. I'm really glad he got to have that time."

Johnnie Haynes was seventy-one when he died, and the little drive-in on Britton had moved down the street into a space twice the size. Four more stores had popped up around the Oklahoma City metropolitan area. Though the store had expanded before he died, Johnnie Haynes was conservative when it came to expansion.

"Growing Johnnie's was really about necessity," Rick Haynes admits. "Dad was raising one family with the store, but when my brother and I came in that added two families to support."

So, the brothers embarked on an aggressive campaign to expand the brand in and out of Oklahoma City. They added a gelato shop next to Johnnie's on Britton Road, expanded to Tulsa and introduced Johnnie's Express stores. They even partnered with chef Eric Smith on Pachinko Parlor, a sushi concept that offered traditional and nontraditional rolls.

Not all of those concepts were successful. Johnnie's never gained traction in Tulsa, Pachinko Parlor never developed a consistent audience and the gelato concept opened around the time of a yogurt shop boom.

Their West on Western Avenue has proven successful enough to warrant a second location in Bricktown, formerly occupied by Nonna's Ristorante. In 2014, they opened Urban Johnnie, an upscale sports bar.

Big Ed's

We have customers who come in now with their kids and grandkids and talk about how they used to eat at Big Ed's when they were younger.
—*Cyrus Naheed, 2009*

When asked for her husband's secret for success in 1983, Jennie Thomas said, "He just thinks big."

Edward L. Thomas opened his first Big Ed's in 1974 with thirty-six cents and a day's worth of supplies bought with promises. "He called his vendors and basically told them, 'I'll pay you back tomorrow,'" daughter Nicole Thomas said in 2009. "But it worked, and it just grew and grew."

Over the next two decades, Big Ed's Hamburgers grew across Oklahoma and into Kansas, boasting forty-two stores. Thomas

Ed Thomas was the founder of Big Ed's, which once boasted more than a dozen restaurants. It opened in 1974. One location remains open today. *Photo courtesy Oklahoma Historical Society.*

entered the restaurant business after ten years as an insurance agent. He had experience cooking and serving food, and the opportunity to open his own business was hard to resist.

Cyrus Naheed was a college student in Midwest City in the 1980s the first time he walked into a Big Ed's store. He said Thomas's secret weapon was his memory. "If you came in and ordered something from him, the next time you came in, he knew your name and your order," Naheed said. "I knew him for 25 years, and I never heard anyone say anything bad about him."

A natural salesman, Thomas served flame-broiled burgers in various sizes, but the Big Ed's Challenge was legendary. Ed Thomas offered a Jumbo Big Ed, which included six quarter-pound patties and a large order of French fries. Anyone capable of downing the Jumbo with French fries in forty-five minutes not only ate for free but also received ten bucks for their trouble.

As growth reached the suburban markets, franchising opportunities arose. "We've had calls from Houston, Arkansas, Nevada and one from New Mexico," Jennie Thomas said in 1983.

But the family's aspirations would be cut short by tragedy. Jennie was hit in a head-on collision in 1986 by a car that had been rear-ended by an uninsured, drunk teen driver. The ensuing two years in the hospital gradually forced Ed to sell the business in 1996. He passed away in 2009, and Jennie died in 2014.

But the spirit of Big Ed's lives on in a shopping center near Northwest 122nd and Pennsylvania Avenue, where owner Cyrus Naheed continues to operate Big Ed's No. 14.

"He told me, 'You've got to build your customers one at a time and then just take care of them,'" Naheed said, pointing to the signed picture of Big Ed hanging on the wall.

Sonic

By the 1970s, drive-ins were losing steam, but Oklahoma City's most prominent drive-in today had just arrived. It started on the outskirts of Shawnee, about forty-five miles east, twenty years before. Seminole native Troy Nuel Smith Sr. and a partner purchased five acres there in 1953.[49] The land included a log house and a walkup root beer stand called the Top Hat, which they operated. They converted the log house into a steakhouse, but the Top Hat averaged $700 a week selling root beer, hamburgers and hot dogs, while the steakhouse was a grind.

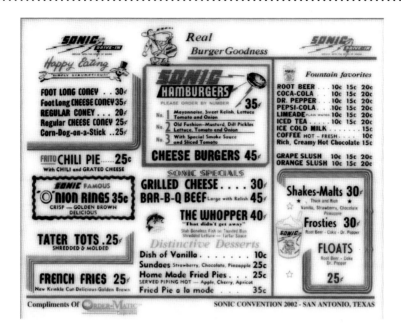

A look at a classic menu from Sonic. *Courtesy Sonic.*

Smith bought out his partner, shuttered the steakhouse and focused on the Top Hat, where customers parked willy-nilly in the gravel parking lot. After Smith converted the Top Hat into a drive-in with two-way speakers and carhops, business tripled. Local businessman Charles Pappe approached Smith about opening a location in Woodward, which they did. By 1958, Top Hat locations were added in Enid and Stillwater.

The name was changed to Sonic in 1959 to go along with an existing slogan, "Service with the Speed of Sound."

The company grew over the next two decades, focusing on small towns in Oklahoma, Texas, Kansas, New Mexico, Missouri and Arkansas. When Pappe died in 1967, Sonic had forty-one drive-ins. The number grew to one thousand by 1978.

In 1983, C. Stephen Lynn was hired as president. The next year, he hired J. Clifford Hudson, an attorney, to head the legal department. Aggressive expansion and redevelopment, combined with a major advertising campaign featuring Frankie Avalon to exploit a trend for 1950s nostalgia, helped grow the company into a national force.

Lynn and a group of investors completed a $10 million leveraged buyout in 1986 and moved their offices to downtown Oklahoma City in 1987. In 1995, Hudson became president and chief executive officer of newly named Sonic

Corp. In the 1990s, the company grew by between 100 and 150 stores annually. Today, Sonic has more than 3,500 locations coast to coast.

SOMEPLACE ELSE DELI

Dave and Peggy Carty met at Oklahoma City University. A New Jersey native, he missed the delis he grew up with and developed a passion for baking. Peggy was working for Crum & Forster Insurance when the couple saved the money and found a space just east of the Gold Dome to open Someplace Else Deli.

"When we first started this, it was just beginning to catch on back here. People were used to hamburgers and my husband, David, was from New Jersey and thought we ought to offer something different," she said. "One of the reasons we opened the store was, there wasn't much around like it."

They opened the deli a year after marrying in 1975. Dave made all the breads, cinnamon rolls, cookies, bagels and other fresh-baked goods, beginning each morning by three o'clock. Peggy ran the register.

The hoagie was long the most popular sandwich, although the avocado, cream cheese and bacon and the Reuben eventually became hits. Someplace Else is still the place for homemade snickerdoodles and chocolate sugar cookies.

NEPTUNE'S

Neptune Submarine Sandwiches was opened in the early 1970s by an Oklahoma man named Ron Taylor. He sold franchises for the submarine restaurant concept across the metro area.

"They were really about the only submarine sandwich shop around at that time," Don Stoneking said.

The last remaining location has occupied the former Quick's Drive-In since 1974. With its faded yellow Formica countertops, the aura of the 1970s hangs as thick in the air as the smell of fresh-baked bread.

The Stonekings' establishment has long outlived the rest of its sister restaurants and is the last surviving of the Neptune chain. In the early 1980s, there were seventeen stretching from Norman to Enid. Neptune, famous for its fresh-baked bread, had its corporate headquarters and bakery near Interstate 35 and Southeast Eighty-ninth.

Chapter 17
GLOBAL CUISINE

Papa Dio's

Jack Sussy's, Tony's Via Roma and Nicolosi's carried the banner for Italian food over the decades, leading the way for Tony's Italian Specialties at 2824 North Pennsylvania, which became a neighborhood hangout into the late 1990s. Tony's featured all the Italian restaurant trappings, including checked laminate tabletops, assorted figurines and posters from Italy on the walls. The jukebox spouted mostly Frank Sinatra standards. After it closed, chef Bruce Rinehart took over the building and opened Rococo, which has offered East Coast style and attitude in the space for more than a decade.

But the Italian restaurant from the 1970s still showing no signs of slowing came by way of Danbury, Connecticut. It was there that William F. Bonadio, whose father came to the area by boat from Calabrese, Italy, made a living with the food of his ancestors after earning the Korean Service Medal, two Bronze Stars, a UN Service Medal and a Combat Infantry Badge. Bill married Constance Bazarian in 1955. Four children and sixteen years later, a relative lured them to Oklahoma, promising peace and quiet on the prairie. That's where Bonadio Jr. opened his first restaurant in 1979.

"My first venture was Dio's Original Fried Pizza," Bill Bonadio Jr. said. "It was just across the parking lot where Tana Thai is now."[50]

It struggled to compete with chains like My Pi in Lakeshore Mall. Bonadio Jr. turned to his father's advice, which was to do tried-and-true Italian.

Bill Bonadio Sr. was the inspiration for his son's restaurant, Papa Dio's, which is still in operation today. *Photo courtesy Oklahoma Historical Society.*

"When we moved here, there wasn't much Italian food. It was Tony's Italian Specialties and not much else, and that wasn't too close to us," said Bill Bonadio Jr. "So, I changed the name of the restaurant to Papa Dio's, in honor of my father."

Bonadio bought out his dad in 1981. At the height of its influence, the Bonadio family had two Papa Dio's locations, and sister Candace Gideo owned Papa's Little Italy on Interstate 35. In 1996, he partnered with Bill Mathis to expand the restaurant with a wine bar, and it still operates today.

Chinese Dynasty

A 1977 story in the *Oklahoman* reported that the city was home to twenty-four Asian restaurants, of which three served Japanese cuisine, the rest Chinese. The grand dame was Golden Pheasant, which, after many years, moved from its original home on China Street at 102 North Broadway to North May Avenue, which had become a new enclave for the local Asian community and home to new Chinese restaurants like Chow's, which still operates.

George Fong, who had a stake in Golden Pheasant for a while, eventually opened his own place with Hoe Sai Gai in Shartel Station. Fong was also part owner of Tony's Via Roma from 1960 to 1970. When Hoe Sai Gai closed, it became Golden Dragon, which operated for nearly three decades and was among the first to serve Mongolian barbecue. In Warr Acres, just west of the city, the Tse family opened Canton Chinese Restaurant, which continues to serve classic Chinese American cuisine.

Michael Sheung opened August Moon in the 74 South Shopping Center at South Pennsylvania and Interstate 240 in 1976. The original red-and-black-lacquer decor was remodeled in 1985. Only the traditional light fixtures and a little waterfall that spilled into a goldfish pond in the main dining room survived. The rest of the interior was replaced with mirrored walls, bright-green and white furnishings and wood accents.

August Moon was representative of local Chinese restaurants like Aloha Garden, Hunan in Casady Square and Mandarin Chinese and American restaurant in Del City, with a Bo Bo tray including barbecued ribs and shrimp toast along with chicken thigh skewers. Entrees included sweet-and-sour pork along with the expected chicken chow mein, chop suey, egg rolls and egg drop soup.

Chinese lunch buffets would find the city in the 1980s, but the most significant development for Oklahoma City dining came when Vietnamese refugees arrived in the United States after the fall of Saigon in 1975. Refugees leaving an internment camp in Arkansas bound for California found opportunity in Oklahoma City. Many would settle in and around the neighborhoods bordering Northwest Twenty-third Street and Classen Boulevard, which today is the city's Asian District.

EL CHARRITO'S CHILDREN

Maria Alvarado's brothers took cues from her and her husband to build El Chico into a juggernaut that stretched from Dallas, across Texas and into Louisiana. It became the toast of Texas, hosting movie stars as they came through Dallas and even catering a centennial celebration in Monaco for Princess Grace, the former film star Grace Kelly. In 1968, the company went public with a 172,000-share offering of its common stock. Key to that move was a merger with El Charrito. Alvarado's stores outside the city became El Chico units, with Oklahoma City stores initially called El Charrito y El Chico. The El Charrito name was phased out completely in short order. The Cuellar brothers sold controlling interest of El Chico in 1974 to a Dallas holding company called Hela. El Chico had grown to seventy-seven units at the time.

Luis Alvarado died in 1977, and the El Chico operating in the original El Charrito No. 1 closed for good in 1987. The Alvarado family, however, was nowhere near finished selling Tex-Mex in Oklahoma City, and Luis Alvarado's legacy continued in myriad new concepts.

One of Alvarado's longtime employees, Mino Hernandez, opened La Roca Grande—La Roca for short—in 1974. Hernandez brought Gilbert Alviso with him. Alviso was a chef at El Charrito before coming to La Roca. He then moved on to Cocina De Mino and Chelino's restaurants.

Hernandez sold La Roca to stepdaughter Cindy Cabrera, who would eventually change the name to La Luna, open a south-side location with a bakery in 1977 and expand to Norman and Newcastle. It closed in 2015.

Hernandez's son Mario and Mario's wife, Leticia, opened Cocina de Mino with a few tables in a home with Mino's help. Cocina de Mino proved to be a hit, expanding to Tulsa and then Kansas City. There were also seven locations in Oklahoma City, including the original store at 327 Southeast Twenty-ninth, which opened in 1982.

Cocina de Mino, like El Charrito before it, became a springboard for future restaurateurs like Ana Davis of Café do Brasil, the city's only Brazilian restaurant.

"I worked as a manager at Cocina de Mino Mexican restaurant for Leticia Hernandez," said Davis. "From that little lady I learned everything, from cooking and food presentation to greeting customers at the door and making them feel special."[51]

Cocina de Mino was sold in 2000; one remains in operation on South Western.

Tulio Ramirez came to the United States in 1963 from Mocupe, Chiclayo, Peru. He settled his family in Oklahoma City, where he met and learned the restaurant business from Alvarado. Tulio eventually opened his own, El Chalan, on South Robinson in an old El Charrito. It would also become the first Tulio's Mexican Café, which grew from Norman to Penn Square Mall in 1989. Tulio died in September 2015. His family still operates Tulio's in Norman.

Casa Bonita

Bill Waugh was born on August 2, 1935, in Norman and graduated from Colorado Springs High School in 1953. He graduated from Abilene Christian University with a fine arts degree in 1959 and then moved back to Norman to start Casa Bonita in Oklahoma City in the summer of 1968 with his wife, Evelyn.

El Charrito had long been established and was on the verge of assimilating with El Chico. El Rancho Sanchez had already introduced cafeteria-style dining to Mexican fare. But Casa Bonita followed the lead of Pancho's Mexican Buffet, which originated in El Paso in 1958 and would eventually come to south Oklahoma City and operate until 2012. At the restaurant, a flag was planted on each table that diners could scroll from bottom to top when they were ready for more food. Meals cost $1.47 that first summer.

When Casa Bonita first opened, the line to get a table stretched through the parking lot, all the way out to the road, recalled Beth Waugh Makibbin, cousin to Bill Waugh.

There were no margaritas or Mexican beer on the menu at Casa Bonita. Bill Waugh was adamant about not serving alcohol. "He was a Christian man and wanted a place where families could go eat without having to expose their children to people drinking alcoholic beverages," Makibbin said.[52]

CLASSIC RESTAURANTS OF OKLAHOMA CITY
· ·

With its elaborate theme rooms, including one that originally looked like a Mexican jail, Casa Bonita was so successful that Waugh eventually expanded to Little Rock, Fort Worth and Lakewood, Colorado.

"It's one of those places that almost anyone who lives in Oklahoma City who was alive at that time remembers working or eating there," said Marc Hader, district four commissioner for Canadian County, who worked at Casa Bonita as a student.

The Colorado Casa Bonita restaurant turned forty in 2015. It features a thirty-foot indoor waterfall with cliff divers and was included in a popular episode of *South Park*.

Waugh sold his interest in 1981. The concept changed corporate hands a few times before Oklahoma City's location closed on Labor Day 1993.

Waugh went on to create several other successful regional restaurant chains, including Burger Street, Taco Bueno and Crystal's Pizza & Spaghetti, which was Oklahoma City's place to go for children's birthday parties. Waugh started it in Abilene, again relying on all-you-can-eat service, but Crystal's had a video arcade and mini-theaters for kids to watch cartoons.

Zamudio's

Francisco Zamudio had spent nine years as escort to President Porfirio Diaz when Pancho Villa began his revolution. Zamudio's close association with Diaz made him a marked man, so he headed north on foot, sleeping by day and wondering if he would ever see his family again. He wouldn't.

Working his way north to Ada, Oklahoma, Frank Zamudio found a home, a wife named Mary and a job as a section hand with the Katy Railroad. Zamudio's friends raved about his tamales, which inspired him to buy a cart. Great response led to a restaurant called Zamudio's. When one restaurant couldn't meet demand, he built more. The last, established in 1936, was built around a huge elm tree that grew through the middle of his living quarters, through the restaurant and out of the roof. He built a brick wall around the tree wide enough for his patrons to sit on. The structure landed Zamudio's in *Ripley's Believe It or Not!* in the 1930s.

When Frank died in 1943, oldest sons David and Thomas carried on the family business—David in Ada and Thomas taking the Zamudio tradition to the big city. Thomas Zamudio settled in Midwest City, first at 6223 Southeast Fifteenth and then at 6308 East Reno, from 1951 to

1986. Zamudio's salsa was sold in grocery stores, called Senor Z's, for another twenty years by Zamudio's daughter and son-in-law.

TACO MAYO

Originating in Norman, Oklahoma, in 1978, Taco Mayo established three stores in Oklahoma City by 1980. Now it's a regional operation with franchise locations throughout Oklahoma, northern Texas, southern Kansas and western Arkansas—more than sixty locations in all.

Once known for low prices, including promotions for tacos as cheap as nineteen cents, Taco Mayo transformed itself in 2012, emphasizing a fresh-Mex menu with a burrito bar setup not unlike Chipotle, as well as classic taco-stand standards.

Chapter 18
HOME COOKIN'

APPLEWOOD'S

Dick Stubbs began working in restaurants as a twelve-year-old growing up in Henryetta. This led him to Oklahoma State's School of Hotel and Restaurant Administration. After a stint in the U.S. Army, Stubbs went to work for the Great American Restaurant Co., which took him back to Stillwater. There, he hired David Egan, a Tulsa native who was an undergraduate at OSU also studying hotel and restaurant management.

The two have not worked apart since.

After Great American brought the two to Oklahoma City to operate stores there, in Stillwater and in Tulsa, Stubbs and his wife, Tina, ventured out on their own in 1978 and brought Egan along, eventually making him a partner.

Spending a whopping $1 million, they called their establishment Applewood's. Located near Reno and Meridian and the strip leading to Will Rogers World Airport, the place was an instant success. Applewood's had much in common with the successful smorgasbord/cafeteria concepts that preceded it, but it offered full service and legendary apple fritters and homemade rolls with "real country butter."

As diners entered, they could see those fritters and rolls being prepared in a small bakery. Baskets of hot fritters were circulated at a rate only slightly faster than the rolls. Four dining rooms were built around an atrium, brightened by towering greenery. If diners chose an appetizer, it would've

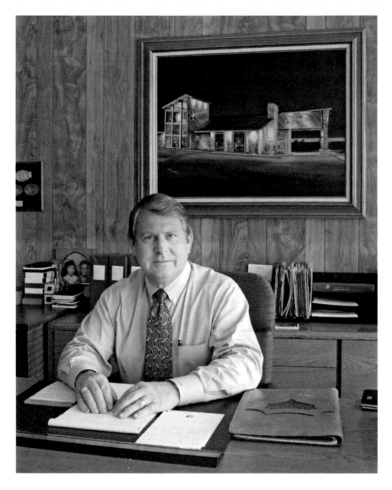

Dick Stubb's founded Applewood's restaurant and now owns Cattlemen's Steakhouse. *Photo courtesy Oklahoma Historical Society.*

been shrimp cocktail, escargot, chicken livers or cheese soup, but Stubbs said that few things sold more briskly than the Green on Green Salad with house dressing and the Waldorf salad. Entrees included a variety of steaks, fried chicken and shrimp, pot roast and baked pork chops marinated in apple cider.

Applewood's was a runaway success, leading to another location on Northwest Highway and seven bakeries scattered around town.

"We didn't realize we were in the middle of an oil boom," David Egan told me. "We were young, and all we knew was there was a lot of people spending money and we had an opportunity to create places for people to spend it with us."

Stubbs even began construction on his dream restaurant, the Velvet Dove—an upscale, prixe fixe fine-dining concept for which he's spared no expense. It would open in September 1982.

Unfortunately, the Velvet Dove was one of many dominoes destined to be knocked over thanks to the failure of the Penn Square Bank just two months prior. The reckless and, in many cases, illegal practices at Penn Square would bring nearly four decades of prosperity and growth in Oklahoma City's economy to a screeching halt. A Darwinian period in Oklahoma City dining ensued.

Ann's Chicken Fry

Ann's Chicken Fry House started life on Route 66 in 1948 as a Cities Service gas station, then Coronado Inn and, later, Three Bull's Steakhouse in 1966.

In 1971, brothers Alvin and Jerry Burchett bought the building and converted it into a nostalgic restaurant specializing in comfort foods in a setting that depicted a better time. Jerry moved to Arkansas decades ago, leaving brother Alvin to run the original and a second location on Northwest Tenth for a few years.

Burchett, a U.S. Grant High School alum, was a car collector who owned a 1927 Ford, 1964 Falcon and 1965 Galaxy. "I'm the kid from the Fifties and Sixties. What I'm trying to do is make a place people our age can come to and kinda look back to high school and things."

Alvin Burchett, founder of Ann's Chicken Fry House. *Photo courtesy the Oklahoma Historical Society.*

Business was always good, but in the summer of 1993, Burchett hired a painter to install a mural on the exterior that drivers couldn't miss from either direction. Traffic got heavier, even if much of it involved drivers who parked their vintage cars in front of the vintage cars painted on the walls for photographs.

Steeped in nostalgia, this Route 66 landmark—notable for the Pepto Bismol–pink Cadillac and vintage police car parked out front—elevates the humble chicken fried steak to high art. Try it the way it was meant to be eaten, with mashed potatoes and cream gravy, ordered with a side item of your choice. Ann's also boasts wonderful fried chicken and fried green tomatoes, as well as salads, chili, hamburgers and more. Save room for dessert and sample deep-fried peaches or coconut pie. Lunch specials are served Tuesday through Friday, and a children's menu is available daily. Ann's Chicken Fry doesn't accept credit cards, so make sure to bring cash when you visit.

"I started here in 1971, when I was 16 years old, and it's the only job I've ever had," Lou said. "We have some wonderful people who come here and 95 percent of the customers are just wonderful; I've grown up with most of them."

INTERURBAN

Robert Ross and Rusty Loeffler opened the Interurban Eating House in 1976 in Norman's historic interurban station. They were young and ambitious, seeking their fortune in the hospitality business.

It would be five years and two openings in Tulsa and one in College Station, Texas, before they entered the Oklahoma City market, in Northpark Mall.

After opening twenty-six concepts from Oklahoma City to Tulsa to Austin, Texas, Ross and Loeffler joined forces with their children to make an original addition to downtown Oklahoma City with Packard's New American Kitchen, located where Automobile Alley meets Midtown at Northwest Tenth and Robinson.

Packard's, which took more than a year to plan and execute, is in an elegant industrial space that's bathed in natural light by day and converts to an intimate, low-lit restaurant by night. The food is an amalgamation of the experience of Loeffler, Ross and his daughter and consulting chef Maggie Humphreys, who designed the menu.

LEO'S BARBECUE

As Hans entered its fifth decade and the Hickory House and Glen's matured into their third, wood-fired pit barbecue gained new popularity and bred new competition.

Most prominent was Leo's Barbecue, owned by Leo Smith. Leo worked as a server under John Bennett at the Cellar, which was as good a place to make money waiting tables as one could find. Leo saved his money and opened in 1974 at the age of thirty-seven.

He spent the remainder of his twenty years operating Leo's restaurants, starting at Northeast Thirty-sixth and Kelley and adding spots from Norman to Edmond. Leo's follows the time-tested tradition of wood-smoked barbecue, serving ribs, brisket, pulled pork and bologna. The hot barbecue sauce is capable of triggering a four-alarm fire. But perhaps the most famous item Leo's serves has nothing to do with barbecue.

A split-level banana cake, known as the strawberry-banana cake, is the only dessert on the menu. It features layers of cake and fresh-sliced bananas topped off with more cake, bananas, fresh-sliced strawberries and a sugar glaze.

Leo died in 1994, at which time his son Charles took over. When Guy Fieri and the *Diners, Drive-Ins and Dives* crew came to Oklahoma City for the first time, it was Charles who appeared on camera. Charles still operates Leo's at the original location, fending off fire and the tax man along the way but never without losing his sense of humor and his sense of barbecue.

CLASSEN GRILL

Classen Grill has been one of the city's most popular breakfast stops since it opened. But for the first fifteen years of its existence, it also offered an upscale dinner menu and wine list.

Tupper and Linda Patnode opened Classen Grill in 1980. Tupper learned to cook working at Chez Vernon, and Linda was an actress and playwright. As friends of the arts, they covered the walls with local artwork. The humble café on the Classen Traffic Circle is routinely voted to the top of "Best of" and "Favorite" lists. When the Patnodes opened the restaurant, dinner was offered, and the menu was ambitious for its time. Instead of a hearty chunk of beef and creamy gravy common, Classen Grill's chicken-fried steak was a thin, tenderized steak served rare with a peppery, translucent gravy. Other

main dishes included grilled chicken breast, lamb chops, pork chops, lamb fries and filet of sole. Steaks included a tenderloin filet sold by the ounce. Classen Grill Potatoes, mashed potatoes with herbs, rolled breading and fried, are still a staple.

The restaurant was sold to Peter Holloway's Holloway Restaurant Group in the early 1990s. Lory and Michael Jones, who helped open Café 501 in Edmond, owned the restaurant for a few years before selling it to open their Lottinvilles Wood Grill concept, which still operates in Edmond.

Today, the Classen Grill chugs on, serving lunch and breakfast plus fresh-squeezed orange juice from the Zumoval.

JIMMY'S EGG

The attitude and concern for customers stems back to the original owner, Jimmy Newman, who sold the May Avenue store to Vietnamese refugees Loc and Kim Le in January 1980.

Newman established the general atmosphere of the restaurant, a feature Kim Le liked enough to begin eating breakfast there before opening her wig shop each morning. When she heard Newman had the restaurant for sale, she convinced her husband, then an inspector for the Santa Fe Railroad, to buy it.

Shortly after buying Jimmy's Egg, Le sold her three High Fashion Wig stores in Oklahoma City and Amarillo and began working full time with her husband, who did not quit his other job for another six months.

Loc and his wife were raised in well-to-do Vietnamese families. He worked for his father during college, became a real estate broker, owned a trucking company and dabbled in construction. His partnership in a food cannery that sold C-rations to the military made it impossible to stay after Saigon fell. The commercial fishing vessel he owned made it possible for thirty members of his family to flee Vietnam.

"I lost everything," he said. "I supported the war. When Saigon fell, I couldn't stay with the Communists."

He was thirty-six when he came to America. Today, Jimmy's Egg has expanded to sixteen local locations and thirty-eight overall, counting franchises in Kansas, Missouri, Texas and Nebraska.

"Work is my hobby," he said. "If I retire, I die."

BUST TO BOMBING TO BIG LEAGUE CITY

The oil bust of 1982 ruthlessly put down dozens of restaurants. The aftermath was the demise of not only fledgling restaurants but also historic ones like the Anna Maude Cafeteria, which closed in 1987—four years after its namesake died at the age of ninety-six. Adair's properties gradually disappeared, as did a chunk of Val-Gene's concepts and a promising new restaurant in Edmond from Chris Lower called the Roosevelt Grill. It was a haymaker to the historic Skirvin Hotel, which employed many of the dining industry's most influential people throughout its history. The Skirvin would shutter in 1988 and hibernate for nearly two decades. Spectacular adult playgrounds like Bob Sullivan's eponymous restaurant and chef Larry O'Hair–driven Michael's Plum, opened to cater to the nouveau riche, became untenable.

As local independents began to fall like dominoes, chain restaurants popped up in their place. The bombing of the Alfred P. Murrah Federal Building thirteen years later brought further hardship, but it would prove to lay the foundation for progress. Local restaurants rallied from that tragedy and killer tornadoes that followed in years to come.

Today's restaurant scene is as vibrant and solid as ever, with a number of current operators showing all the signs of becoming the historic restaurants of tomorrow. But it was a response to a distress call that most shaped the future of Oklahoma City dining in the aftermath of the bust.

Chapter 19
CATTLEMEN'S CAFÉ TO CATTLEMEN'S STEAKHOUSE

Sit back into a time when things were done right—The Cattlemen's Way.
—2013 advertisement

Dick Stubbs took two gambles in 1982—one good one, one bad one. The Velvet Dove's timing couldn't have been worse, and the bakery business proved to be an anchor on growth. The other gamble was one he was asked to take on behalf of a friend. It proved to be the best gamble he ever took.

"Gene Wade was a friend of mine, and we happened to have the same banker," Stubbs said. "The banker called me one day and asked me, really told me, to help Gene out."

"It was struggling," Stubbs said. "Like most restaurants at the time, the 1980s hit really hard. Interstate 40 was closed for about eighteen months near Agnew (the main entrance to Stockyards City), so consequently business had fallen way off. It was still seeing three thousand customers a week, but not enough to make any money."

So Stubbs entered a management agreement with Wade with an option to purchase in eight years. Stubbs's first move was a new, aggressive marketing plan.

"We were still feeling the effects of the bust," Stubbs explained. "We felt like people might be feeling a little nostalgia for the way things used to be before it."

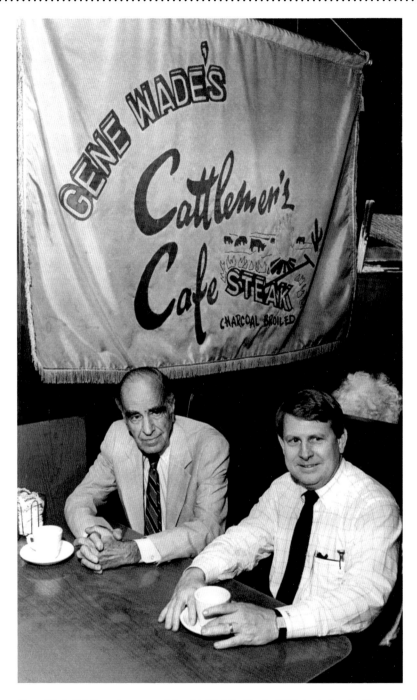

Gene Wade (*left*) forged a partnership with Dick Stubbs in 1982 that led to Stubbs purchasing the restaurant eight years later. *Photo courtesy Oklahoma Historical Society.*

They were right. Radio spots around Oklahoma and a TV commercial extolling the good ol' days helped Cattlemen's not only return to viability but explode. The restaurant changed from an all-night diner to regular hours (7:00 a.m. to 10:00 p.m.). Breakfast cut off at 11:00 a.m. The Cattlemen's Café sign stayed up, but henceforth the restaurant has been known as Cattlemen's Steakhouse, featuring upgraded choice steaks aged in-house and a special blue-ribbon menu of prime selections.

"We were looking to open a steakhouse at the time," Stubbs said. "With Glen's [Hik'ry Inn] and Christopher's gone, and Eddy's struggling, it was a good time to get into the marketplace and convince people we had good steaks."

Lamb fries and the secret creamy salad dressing remain on the menu. Stubbs and Egan also improved the wine list.

"The only mistake was not being able to take over sooner," Stubbs said through a wry grin. "I thought it would take at least that long to turn it around, but we were in the black within five years."

Part of the secret to Cattlemen's success was a surprise visit from President George Herbert Walker Bush in 1992.

"We never dreamed the president would come here," cashier Sophia Holland said in a story by Lisa Beckloff for the *Oklahoman*. "I don't know *why*; we *do* have the best steaks in town," she said.

Debbie Rector, who waited on the president, said Bush ordered a T-bone steak—charred but rare—French fries and salad with Cattlemen's dressing. Another waitress, Sharon Myrick, got a few more words from the president earlier when he ordered a martini on the rocks.

"I asked him how his day had gone in Oklahoma City, and if he had enjoyed his day, and he said, 'Yes, I've had a super day,'" Myrick said.

Part of the entourage that night was Senator Don Nickles and his wife, Linda. According to Stubbs, Nickles was key in the president's dinner choice that night.

"They were supposed to go to the Spaghetti Warehouse," Stubbs explained. "But Nickles told him there were a lot more cattlemen than Italians voting around here."

Stubbs said business boomed shortly after the presidential visit and has never slowed. Part of the mission was to clean up the historic Stockyards and participate in a marketing campaign to rehabilitate its image.

"The area had a bad image," Stubbs said. "Security was an issue. It wasn't a tough place, but it had the reputation of being tough from times past."

Property owners organized and petitioned the state to establish Stockyards City as the first urban Main Street program. The neighborhood underwent

a makeover that included new streets, sidewalks and vintage-style lighting. An appearance in the 2003 book *1,000 Places to Eat Before You Die* triggered a steady flow of travel writers, followed by visits from the Food Network's *Diners, Drive-Ins and Dives,* the Travel Channel's *Man versus Food* and a litany of others.

As for Applewood's, Stubbs sold it to Stokely Hospitality Enterprises in 2000. Stokely was already operating a couple of Applewood's restaurants in Sevierville, Tennessee, without permission to use the name.

"The timing on that was pretty good," Egan said. "It gave us some leverage at a time we were anxious to sell."

Applewood's closed just a few years later. But at Cattlemen's, business has improved every year since. In 2010, Stubbs told Steve Lackmeyer of the *Oklahoman* that Cattlemen's served about one thousand steaks to about thirteen hundred people per day.

Chapter 20

THE THEATER OF DINING

Chris Lower was looking for a new start after the oil bust ravaged Edmond and his first restaurant, the Roosevelt Grill. He'd caught the restaurant bug in high school working for John Bennett at the Grand Boulevard Diner and fallen in love with what he called the "Theater of Dining." When Lower's father partnered with attorney and *Oklahoma Gazette* publisher Bill Bleakley to purchase Michael Ashcraft/Charles Peppers concept Les Caveaux, Chris helped convert the Midtown restaurant into the Newport.

Despite warnings that fine dining was dead in Oklahoma City, the young restaurateur looked at the one seemingly recession-proof spot in the metro: Nichols Hills.

"I'd had my eye on Nichols Hills Plaza for a while," Lower said. "There was a space that'd been available I thought would make a great little restaurant."

The available space had been home to a liquor store for years before it closed on November 30, 1984. Lower had the support of his Roosevelt Grill patrons from Nichols Hills, but he had to haggle with the Nichols Hills Planning Commission and city council for a special permit to appease "noise and traffic" concerns.

On November 15, 1985, the Coach House opened with thirty-eight seats, white linen tablecloths, fresh flowers, fine china and real silver. The menu contained French, American and regional specialty foods using seasonal ingredients, plus seafood shipped in from both coasts and Europe.

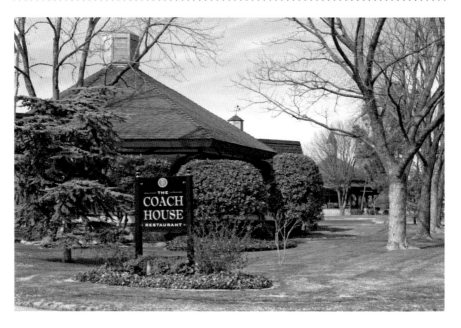

An exterior view of the Coach House, which opened in 1985 and closed in 2016. *Photo by Dave Cathey.*

The buzz surrounding the Coach House was loud enough to catch the ear of a rising culinary star who grew up in Yukon but had traveled through Chicago; Scottsdale, Arizona; and Dallas to improve his skills before returning home to work at the flagging Skirvin Hotel. There he made friends with director of beverage service Michel Buthion, whose brother Alain was cooking at the Coach House. So one night when he was off, Kurt Fleischfresser decided to check out the competition. He found the Coach House packed and knew that the tables at the Skirvin were unoccupied.

"I was looking for a new chef, and I had heard and read about some of the stuff that Kurt was doing down at the Skirvin and was impressed with everything I heard and saw," Lower recalled.

Fleischfresser became executive chef in 1988. Soon after, he started a world-class apprenticeship program, which bred the Coach House philosophy into restaurants of all levels across the city.

Shortly after Lower and Fleischfresser cemented their partnership at the Coach House in August 1988, the former Cappuccino's space at 6418 North Western became available. Fleischfresser sought to develop a bistro menu, and because the location was within shouting distance of the Coach House, the restaurateurs opened the Metro Wine Bar and Bistro.

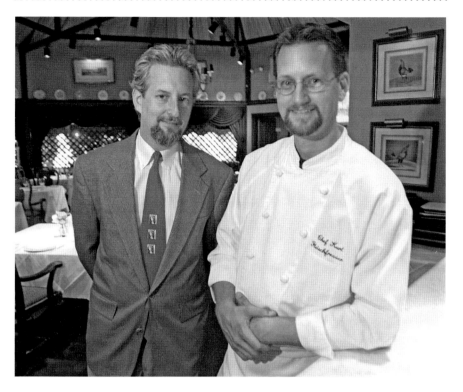

Chris Lower (*left*) founded the Coach House, and chef Kurt Fleischfresser molded it into the standard-bearer for culinary expression for more than three decades. *Photo courtesy the Oklahoma Historical Society.*

"Within three days, Chris was working on a design, and I was working on a menu," Fleischfresser said. "We would get off work, bring old clothes, come across here with hammers and nails."

From the beginning, the Metro was a hit. Fleischfresser could barely keep pace with the demand. "The surprise of the whole deal was that from the day we opened up, we were packed," Fleischfresser remembered. "I couldn't get the stuff in the back door fast enough."

And the Restaurant Resource Group partnership was formed with the Metro Wine Bar and Bistro, Earl's Rib Palace, Irma's Burger Shack, Iguana Lounge, Deep Fork Wood Grill, Ground Floor Café, Montrachet in Tulsa and Portobello.

The Coach House would quickly rise to preeminence in fine dining, filling the void left by the Cellar Restaurant. For thirty years it was the vanguard for culinary art, drawing chefs like Jacques Pepin, Stephen Pyles and Rick Bayless for special events.

When the Restaurant Resource Group dissolved, Fleischfresser kept the Coach House and Lower kept the Metro. They remain partners at Irma's Burger Shack today. The Metro is operated by Lower and his wife, Laveryl. In 2010, Fleischfresser joined Carl Milam's Western Concepts restaurant group, adding the Coach House to Sushi Neko, Musashi's and the Lobby Bar, located in the historic Will Rogers Theatre. Milam, a relative of Will Rogers, had hired Fleischfresser as a consultant, and the relationship evolved into a full-time partnership.

In November 2015, Fleischfresser announced the Coach House would close in February 2016 and open as a new concept in the space shortly after. Lower teamed with Fleischfresser's son Kyle to research and design the new place, with chef David Henry manning the stove. It opened on July 1. While the Coach House's time in history has come and gone, its legacy grows thanks to the forty-one graduates its apprenticeship program produced. Graduates work all over the country, but they have made Oklahoma City their primary playground, ensuring gustatory progress for the foreseeable future.

Fleischfresser became director of culinary services for Vast, the swank restaurant on the fifty-eighth floor of the Devon Tower, on top of his duties at Western Concepts.

Lower opened Big Truck Tacos with chefs Kathyn Mathis and Cally Johnson in 2009. They added Mutt's Amazing Hot Dogs in 2011, which they sold in 2014. Mathis and Lower have continued their partnership to open Back Door Barbecue and Pizzeria Gusto.

Chapter 21
LAISSEZ LES BON TEMPS ROULEZ

Jacques Orenstein introduced French cuisine to Oklahoma City, and John Bennett expanded upon it at the Cellar and inspired its growth. He trained chefs like John Vernon (Chez Vernon), but its popularity wouldn't be fully realized until it was made available to a broader audience starting in the early 1980s.

That's when two immigrant students at the University of Oklahoma opened a French bakery in Norman, the white-hot trend of French-influenced Cajun and Creole cuisine arrived and two sons of a French butcher settled on the prairie.

PEARL'S OYSTER BAR

Paul Seikel's options were so limited in the summer of 1972 that he cut his long hair to get a job.

"I went to Crosstimbers in Norman because friends told me it would be a good place to make some money," Seikel explained to me from his expansive office adorned with photographs of blues musicians and newspaper clippings from a forty-one-year career in the restaurant business. "But I guess they didn't like my long hair, so I went and got it cut, came back and they still wouldn't give me the time of day."

But Seikel, who was a finance major home from college in Colorado, was so desperate that he kept returning until someone finally gave him a job. The

two men he ended up working for at Crosstimbers were named Hank Kraft and Hal Smith. They were a little further along the way to making their mark in Oklahoma City—and national—restaurant history. The following summer, Seikel was invited back to work and made the most of it, picking up enough knowledge to use his finance degree to open the Sub-Way Deli and Grill in 1974.

"My wife had to sign for the liquor license because I wasn't old enough," he said.

To get started, Seikel saved $2,000 and borrowed another $2,000 from the bank. When another deli called Subway, now a national juggernaut, came to town in the late 1980s, Seikel would collect a six-figure settlement and close his concept for good to concentrate on his other holdings, which included a seafood restaurant that started out with the name S&K Oyster Bar.

But before the restaurant opened in October 1983, Seikel, his wife, Linda, brother Michael and partners Fenton Sanger and David Kallenberger settled on Pearl's Oyster Bar. It began as a simple Cajun restaurant but evolved into one of the city's most enduring seafood concepts, with a menu that expanded to include Creole, Southwest, Asian and Mediterranean influences.

Though Paul and Linda divorced years ago, they remain partners in the business. She typically is in charge of interior design. The Seikels had a good inkling that Pearl's would work, thanks to his experience with Harry's Oyster Bar on Northwest Expressway and MacArthur, which opened the year before with partner Bill Shumate.

"We were in the middle of the oil bust. I wanted something smaller where I could replicate the success we had with Harry's."

From the black-and-white-checkered floors to the waiters' white tuxedo shirts, black bow ties and suspenders, Pearl's art deco ambiance made for a fun dining experience that developed a cult-like following. Regulars also partook in daily happy hours on the patio.

In 2007, Pearl's moved its flagship establishment from Northwest Sixty-third Street to Classen Boulevard, on the south end of Classen Curve. The current Belle Isle location expanded Pearl's into an eight-thousand-square-foot space with an expansive patio and private dining options. Seikel also expanded the Pearl's brand into a fast-casual concept called Pearl's Express Cajun Kitchen.

Pearl's moved into Texas markets in the mid-1980s and succeeded for close to a decade. Seikel and Shumate also had Clementine's, Graffiti's, the White House and Sarducci's.

LA BAGUETTE

Michel Buthion left his native Grenoble, France, with an education from Lesdiguere Hotel and Restaurant School and bounced from Paris to Winchester, England, before crossing the pond and making stops in California and Oklahoma. He then took a job at the Skirvin Plaza Hotel in 1981.

He was named food and beverage director in 1987, but timing wasn't on his side, as the historic hotel went into a deep hibernation later that year. But Buthion wasn't deterred. Business was reeling before the bottom fell out of the economy, and he had already encouraged his chef, Kurt Fleischfresser, to seek work at a new restaurant where his younger brother, Alain, worked.

By 1989, Fleischfresser had partnered with Coach House founder Chris Lower to open a second restaurant, and they were busy laying the foundation for Oklahoma City's dining renaissance, which started in the 1990s and continues today. The Buthion brothers were managing partners of La Baguette, a French bakery and bistro at 7408 North May Avenue owned by Johnny Jazzar and his sister Nora Jazzar plus his brother-in-law Rudy Khouri.

Michel and Alain Buthion came to Oklahoma City from Grenoble, France, more than four decades ago. They own and operate La Baguette Bistro in Oklahoma City. *Photo courtesy the Oklahoman.*

That trio opened its first French bakery in Norman across the street from Norman High School in 1984 and would eventually add a second spot downtown before the May Avenue location came available. But that location was in the basement of the Journal Record Building, located across the street from the Alfred P. Murrah Building. When 163 people were killed in the federal building by a domestic terrorist's bomb, La Baguette's downtown location was destroyed.

While Khouri and the Jazzars turned their attention to making La Baguette into a commercial bakery, which now reaches beyond Oklahoma's borders, the Buthions helped turn La Baguette into the city's most popular bistro and helped operate another concept, Cuisine 43, in the mid-1990s.

The Jazzars and Khouri decided to turn La Baguette in Oklahoma City over to the Buthions more than a decade ago, citing their remarkable effort.

"We felt like it was the right thing to do," Rudy Khouri said.

After taking ownership of the North May location in the late 1990s, the brothers added Soleil Restaurant inside the Colcord Hotel and would later purchase and operate Bellini's for several years before selling it.

In the decades since they first arrived from France, Michel and Alain Buthion have become pillars of the local restaurant community, serving the Oklahoma Restaurant Association in many capacities.

La Baguette is now home to a butcher shop, bakery, deli and market as well as a wine bar and bistro. In Norman, Jazzar and Khouri operate two La Baguette locations as well as the commercial bakery, which supplies dozens of local restaurants.

FROM NINO'S TO CHELINO'S

After the demise of El Charrito and Luis Alvarado's retirement, his family got busy opening their own places. Family members still operate two Alvarado's Mexican Restaurants in south Oklahoma City and Edmond, while Pepe's in Edmond and Casa de Los Milagros came from the Julian Gonzalez family, whose matriarch, Taide, was Alvarado's niece.

As with La Roca/La Luna and Cocina de Mino, other former El Charrito employees used the lessons they learned from the Alvarado family to open their own places. Perhaps no one did it as successfully as Cesar Aita, who went by "Nino."

Aita came to the United States from Lima, Peru, and would eventually open his first Nino's Mexican Restaurant with Forrest Pruitt in 1978, just north of Interstate 240 on South Western Avenue. Aita came to Oklahoma City around 1960 and took a job as a busboy at El Charrito. He enlisted and served three years in the army before returning to El Charrito and working his way up to manager as the chain grew. That's where he met a pretty girl named Sonia, who happened to be Luis Alvarado's niece.

Before he sold Nino's in 2006, Aita had opened a total of five Nino's locations plus one barbecue joint. The last three Nino's locations, which were owned by yet another group, all closed simultaneously in 2012.

Sonia and Teresa Aita said the subculture of local Mexican restaurants has always been tightly knit. Growing up in the first family of Oklahoma City's Mexican food community, Sonia said the Alvarados always sought to help others establish themselves. She said when she and Nino embarked on their own concept, they had the full support of her family.

That spirit was passed down from the Aitas to one of their favorite employees, a youngster who showed up one day looking for a job bussing tables. His name was Marcelino Garcia, but everyone called him Chelino.

Teresa Aita said that when Garcia—who in eight years rose from busboy to store manager of the Northwest Expressway location—was ready to go it alone, her father supported him. "Nino gave me a chance," Garcia said. "Whether he is living or not, Nino is my hero. He taught me everything."[53]

Garcia came to Oklahoma City in 1979 at age fifteen with thirty-six cents to his name. He worked ten years for Aita before approaching him about starting his own place, which would feature flavors of his birthplace, Calvillo, Mexico. "When I told Nino I wanted to open my own place, he didn't say anything, he just handed me a key," Garcia said. "The key was to his warehouse. He said, 'Take whatever you need: tables, chairs equipment—anything.'"

Garcia said he took his mentor up on the offer, making a list of things he'd taken on spec. "He told me, 'If it doesn't work out, you can always come back home. You will always have a home here.'"

Garcia did return home, but not as a failure. He came back as owner of thirteen restaurants, two import stores, an ice cream factory, a bakery, a meat market, an event center, a banquet hall and a produce distribution company. And he returned to take over one of the abandoned Nino's concepts in 2013 and convert it into a Chelino's.

"When we opened, I felt all of my emotions at once," he said. "It was like my wedding day."

Teresa Aita said that when Garcia stood to speak at her father's funeral in June 2012, emotion wouldn't allow the words to come. He couldn't express how much Nino had meant to him, but his tears told the tale.

And so did an act of kindness. Teresa Aita said her father struggled with retirement. "Without work, he didn't know what to do," Aita said. "It was a difficult time for him; he was a worker with nowhere to show up."

She said Garcia invited Nino to manage the original Chelino's on Southwest Eighty-ninth. As usual, Aita succeeded. The restaurant performed so well, it was expanded. Teresa said the patio added after her father's arrival was dedicated to him. And Garcia has paid forward Aita's kindness, which he paid forward from Luis Alvarado.

"I count twenty-seven Mexican restaurants that have been opened by people that used to work for me," Garcia said with conspicuous pride. "People ask me if I worry about the competition, but how can I not be happy for them the way Nino was happy for me?"

Chapter 23

RISE OF THE ASIAN DISTRICT

When Saigon fell in 1975, refugees flooded into the United States. Many were assigned to the miserable conditions at Fort Chaffee in Arkansas. Civic leaders and churches from Oklahoma City quickly stepped up to sponsor hundreds of the refugees and bus them here, where they found food, shelter and temporary assistance until they could reestablish themselves. Nearly all of the refugees who settled in Oklahoma City did so in neighborhoods in and around a square bordered by Northwest Twenty-third, Northwest Thirty-sixth, Villa and Shartel. More arrived in the 1980s and 1990s, including the children of former U.S. service members and others who'd suffered as political prisoners in communist reeducation camps.

The flagging business district on North Classen, where Lyle's Chuck Wagon, Kamp's Grocery Store and the Village Inn long operated, was soon home to new Vietnamese businesses. While restaurants in the area, soon called Little Saigon, tended to be Asian, not all were Vietnamese. In fact, one of the Asian District's most storied restaurants, Grand House Asian Bistro, is owned by Thai and Kathy Tien, who are Chinese.

Thai Tien came to Oklahoma City in 1980 by way of Boston, where he lived for four years after his initial emigration from Hong Kong. Kathy's parents left Hong Kong in the 1950s, first moving to Vietnam, where she was born. They then moved to France and from there to the United States in 1982.

The first Grand House was at Northwest Twenty-third, on the corner where the Classen Cafeteria stood years before. Across the street, and a little southeast, was an all-night Village Inn Pancake House.

"Sometimes, when we got off work, we would go there because it was the only place open late," Kathy said.

Grand House was serving the westernized Chinese fare still common on buffets across the country, but when the pancake house closed in 1994, the Tiens scooped it up and turned it into an Asian bistro. "We wanted to represent all the Asian cultures that live here," Thai said.

A menu once populated by Kung Pao, chop suey and fried rice was expanded to include Vietnamese noodle bowls, Peking duck, sushi and pad Thai. A second menu of traditional Chinese preparations was available, along with dim sum on weekends and holidays.

Grand House is the grand dame of a group of long-running local restaurants bridging the gap between traditional Asian fare and General Tso's army of assimilation dishes. Denny Ha's Dot Wo and now Dot Wo Garden, Fung's Kitchen, Szechuan Bistro and Golden Phoenix have changed diners' expectations.

Pho Lien Hoa has been the standard-bearer for local pho, which is as good as you can expect to find anywhere in the world, thanks to the contributions of Vietnamese refugees since the early 1990s.

Tri and Kim Luong were refugees when they opened the Super Cao Nguyen Market, which not only promotes flavors from all over the world but also is landlord to Banana Island, offering Malyasian cuisine, and Mr. Pho.

Gone but never forgotten is Saigon Baguette, where Nhung Ngoc Nguyen, or Mona, introduced banh mi to the prairie and served it for fourteen years, starting in 1990.

Shogun

While Chinese food has been a part of Oklahoma City dining in some capacity since statehood, and Vietnamese food came flooding in with the refugees in the late 1970s and early 1980s, Japanese cuisine has found its footing at a more leisurely pace.

Shogun Steak House of Japan opened its first location on Northwest Fiftieth and Meridian in April 1981, featuring the teppanyaki style made famous by Benihana—which opened a spot for a short time in 1982 in Rockwell Plaza. A second iteration of Shogun opened on South Western a couple of years later in the old Doc Holliday's Club.

The south-side location eventually closed, and the original moved into Northpark Mall, where it still resides. Western Concepts opened its own teppanyaki concept, Musashi's, across the street from Sushi Neko on Western in 2002.

Sushi didn't gain relevance until Tokyo Japanese Restaurant opened on North Western in the late 1980s. It is still considered the benchmark for local sushi, along with Western Concepts' Sushi Neko and Henry Yang's Tsubaki.

Chapter 24
THE NEXT WAVE

Ludivine chef/owners Jonathon Stranger and Russ Johnson invited a group of chefs into their kitchen to help prepare foods to celebrate their farm-to-table restaurant's fifth anniversary in the fall of 2015.

Stranger and Johnson, both Oklahoma City natives, wanted to showcase local talent that was helping to grow Oklahoma City's dining landscape while paying homage to those who inspired their pursuit of the culinary arts.

On hand were up-and-coming chefs like Henry Boudreaux, Chris Becker, Jonathan Krell and Marc Dunham, but also included were members of Oklahoma City's pioneer class of chefs, John Bennett and Kurt Fleischfresser.

The camaraderie and cooperation of three generations of chefs on display that summer night was a microcosm of Oklahoma City dining history, which was founded on opportunity and shaped by desperation but progressed by determination, ambition and commitment to improving the quality of life of its community.

When the next volume of Oklahoma City's restaurants is written in another fifty years, those names will all figure prominently, as will many others still living their stories at this printing.

The Blevins brothers started City Bites in 1986, and today the deli concept has grown into a regional chain. VZD's began as a live venue in 1976 in the historic Veazey's Drug Store on Western, where it introduced music's future stars to local audiences for a couple of decades before becoming an enduring neighborhood eatery under Chad Bleakley and now under chef Eric Smith and Nelson Bolen.

When Ingrid Simon bought Dutch Treats in 1975, she bought her bread from Irene's Bakery. Pretty soon she bought Irene's and merged it with Dutch Treats and called it Ingrid's Kitchen, which flourished for years as a German bakery that dabbled in breakfast and lunch while specializing in European bread. When Ingrid decided to retire in 2001, local caterer Lee Burrus bought the business and has expanded it with help from Ingrid's son-in-law and head baker Greg Spitler. Today, Ingrid's has evolved into a full-scale restaurant and added two locations. Live music still draws dancers of all ages from noon to 2:00 p.m. on Saturdays.

Keith and Heather Paul's A Good Egg Dining group features Iron Star Urban BBQ, Cheever's Café, Tucker's Onion Burgers, the Drake, RePUBlic Gastropub, Red Primesteak and Kitchen No. 324.

Chef Ryan Parrott and partners Shaun Fiaccone and Kim Dansereau first worked together for the Deep Fork group and now oversee Picasso's Café, with plans for more in the Paseo District.

Tommy Byrd founded Bellini's back in 1990 and Tommy's Italian-American Grill shortly after, along with a string of other successful concepts. His Tommy's reopened in 2014 after an extended sabbatical.

Chef Sean Cummings blew into Oklahoma City in the early 1990s from Kansas City. After working for a while at the white-hot but short-lived TerraLuna, he brought his new bride, Cathy, to town to open seafood concept Boca Boca, then Sean Cummings Irish Pub. Meanwhile, Cathy brought the flavors of her Italian American heritage to town through Vito's Ristorante, which thrives today.

About twenty years ago, a landscaper named Justin Nicholas, whom everyone calls Nic, bought a property near Northwest Tenth and Pennsylvania Avenue. The property included a home and a tiny street-front restaurant, long home to Marcia's Café and Marcia's Sister's Café. Nicholas harbored a long-standing dream to own a restaurant and made it come true in Nic's Grill, which has been the object of adulation by multiple national magazines, books and television programs. It was even featured in an international magazine.

"A friend of mine sent me a link to this story about us, but it wasn't in English," Nicholas explained. "So, I showed it to a buddy who speaks Spanish and he took a look at it. Then he turns to me and says, 'Nic, that ain't Spanish, it's French.'" The publication was *French GQ.*

Nic's has been featured on *Diners, Drive-Ins and Dives* and mentioned on *The Tonight Show Starring Jay Leno.* With Nic's Diner due to open in 2016, its owner's place in Oklahoma dining history is still bearing itself out.

More recently, Midtown has become home to hit concepts like Ludivine and its sister concept, the R&J Lounge and Supper Club. Also populating the area are McNellie's Pub, Tamashii Ramen and Yakitori, Elemental Coffee, Stella Modern Italian and Ana Davis's Café do Brasil.

The Plaza District has flourished thanks to urban renewal led by restaurants like the Mule, Goro Ramen + Izakaya, Saints Irish Pub, Empire Slice House, Pie Junkie and Roxy's Ice Cream.

Concepts like S&B Burger Joint will join Johnnie's Charcoal Broiler. Chefs like Vuong Nguyen, Taylor Desjarlais, Joseph Royer, Leo Novak, Beth Ann Lyon, Josh Partain, Jonathan Groth, Josh Valentine and Clay Falkner will be the subjects of retrospect.

With culinary influences from Peru, Malaysia and Guatemala joining Japan, China, Vietnam, Mexico, Brazil, France, Italy, Germany and the Middle East, the culinary landscape is still an untamed frontier. That means the stories to come promise to be as full as those from the past.

For one night, as local chefs young and old gathered at Ludivine, the capacity crowd stood and gave the chefs a rousing ovation. No doubt the applause echoed through heavenly corridors to a grand dining hall, where a diminutive pair of restaurant giants named Beverly and Anna Maude, surrounded by those they'd led into the restaurant business, shared in the glory.

NOTES

PART I

Chapter 1

1. Zeaman, "Kaiser Tradition Continues."
2. *Daily Oklahoman*, "Burglars Pass on When These Bow-Wows Growl!"
3. Victor, "Anna Maude Celebrates a Tradition She Founded."
4. Ibid.
5. Nichols, "Employees Provided Special Feeling at Anna Maude."

Chapter 2

6. Dowell, "Readers Bring Back Fond Memories."
7. Driskill, "Beverly Osborne: From Shoeshine Boy to Millionaire."
8. *Oklahoman*, advertisement, 1928.
9. Goff-Majors, "Summer Job Turns into 50 Year Job."

Chapter 3

10. Hatch, "Ride to Top Bumpy but Worth It."

Chapter 4

11. Denton, "City Barbecue Landmark Closing."
12. Posey, "Chinese Seeks Roots, Answers in City."

Chapter 5

13. *Oklahoman*, "Stock Yards Bank's History Colorful."
14. Sutter, "Cafe's Owner Marks 40th Year in Business."

PART II

15. Hatch, "The Country's Biggest Bowl of Chile."

Chapter 6

16. Jackson, *nDepth Stories of the Ages*.
17. Sutter, "Cafe's Owner Marks 40th Year in Business."

Chapter 7

18. Dowell, "Ichabod Crane Isn't at Sleepy Hollow, Just Good Food."
19. Ibid.
20. Ibid.

Chapter 8

21. Hatch, "He Looks Up at Downtown."
22. Denton, "35th Anniversary Cafeteria Celebrates Serving City's Tastes."
23. Lee, "1907 Forty Tickets On Sale."
24. Denton, "35th Anniversary Cafeteria Celebrates Serving City's Tastes."
25. Lackmeyer, "Queen Ann Ends Reign."
26. Lackmeyer, "Advent of Liquor Sales Posed Danger in Oklahoma."
27. Reports, "Executive Hurt in Lake Mishap."
28. Reports, "Cafeteria Relocation Upheld."

Chapter 10

29. Hatch, "The Country's Biggest Bowl of Chile."
30. Nichols, "Samara Made a Living on Always Trying Something New."
31. Reports, "City Briefs."
32. Lee, "Trivialities Involving Oklahoma, Global Geography."
33. Lee, "Sidewalk Too Narrow Along Canal."
34. Reports, "Variety Spices Pizza Offerings."
35. Gilmore, "Nicolosi's Combines Variety, Charm."
36. DeFrange, "City Family Passing On Eatery, Secret Recipes."

Chapter 11

37. Brown, "Green Scene."
38. Dowell, "Reader Fills in Gaps about Glen's."

Chapter 12

39. Owen, "Split-T: Memories Hot Off Grill Eatery Shuts Doors on Era."
40. Donovan, "Golden Arches to Replace Landmark Pig in Pinstripe."
41. Medley, "Memories of the Big Pig Live On."
42. Medley, "After Half Century, Charcoal Oven Owner Says He's Having Too Much Fun to Sell."
43. Miller, "City Couple's Drive-In Grows into $8 Million-a-Year Chain."
44. Pemberton, "Del Rancho Continues to Expand."

Chapter 13

45. Reports, "Former Restaurant Owner Dies."
46. Hevesi, "Clara Luper, a Leader of Civil Rights Sit-Ins, Dies at 88."

PART III

Chapter 14

47. Taylor, "Margaret Pearson Cleared of Killing."
48. Cathey, "Jamil's Steakhouse."

Chapter 16

49. Blackburn, *Sonic: The History of America's Drive-in.*

Chapter 17

50. Cathey, "Every Day Is Father's Day at Papa Dio's."
51. Cathey, "Cafe do Brasil Is a Slice of Oklahoma City's Story."
52. Bailey, "Bonita Memories."

PART IV

Chapter 22

53. Cathey, "Chelino's Proves You Can Go Home Again."

BIBLIOGRAPHY

Bailey, Brianna. "Bonita Memories." *Oklahoman*, September 16, 2015.

Blackburn, Bob. *Sonic: The History of America's Drive-in.* Oklahoma City, OK: Cottonwood Publications, 2009.

Brown, V. "Green Scene." *Oklahoma Today* (May/June 2008): 46.

Cathey, Dave. "Cafe do Brasil Is a Slice of Oklahoma City's Story." *Oklahoman*, January 23, 2013.

———. "Chelino's Proves You Can Go Home Again." *Oklahoman*, March 6, 2013.

———. "Every Day Is Father's Day at Papa Dio's." *Oklahoman*, June 16, 2010.

———. "Jamil's Steakhouse." *Oklahoman*, March 25, 2010.

Daily Oklahoman. "Burglars Pass on When These Bow-Wows Growl!" February 21, 1926.

DeFrange, A. "City Family Passing On Eatery, Secret Recipes." *Oklahoman*, February 20, 1988, 26.

Denton, J. "City Barbecue Landmark Closing." *Oklahoman*, October 6, 1990.

———. "35th Anniversary Cafeteria Celebrates Serving City's Tastes." *Oklahoman*, March 5, 1989, 1C, 3C.

Donovan, K. "Golden Arches to Replace Landmark Pig in Pinstripe." *Oklahoman*, May 20, 1982, A1, 2.

Dowell, S. "Ichabod Crane Isn't at Sleepy Hollow, Just Good Food." *Oklahoman*, April 18, 1999, 90.

———. "Reader Fills in Gaps about Glen's." *Oklahoman*, October 27, 1999, B1, B3.

———. "Readers Bring Back Fond Memories." *Oklahoman*, October 27, 1999, 20.

Driskill, G. "Beverly Osborne: From Shoeshine Boy to Millionaire." *Sunday Oklahoman/The Oklahomans*, March 18, 1979, 4–7.

Gilmore, G. "Nicolosi's Combines Variety, Charm." *Oklahoman*, May 23, 1984, N-10.

Goff-Majors, K. "Summer Job Turns into 50 Year Job." *Oklahoman*, May 23, 1987, 12.

Hatch, K. "The Country's Biggest Bowl of Chile." *Oklahoman*, December 8, 1968, 46.

———. "He Looks Up at Downtown." *Daily Oklahoman*, June 25, 1967, 7, 12.

———. "Ride to Top Bumpy but Worth It." *Daily Oklahoman*, January 21, 1968, 7, 9.

Hevesi, D. "Clara Luper, a Leader of Civil Rights Sit-Ins, Dies at 88." *New York Times*, June 11, 2011.

Jackson, R. *nDepth Stories of the Ages: "A Hard Six."* Newsok.com, December 2012. Retrieved April 15, 2015. http://ndepth.newsok.com/hard-six.

Lackmeyer, S. "Advent of Liquor Sales Posed Danger in Oklahoma." *Oklahoman*, August 30, 2009, 1C, 6C.

———. "Queen Ann Ends Reign." *Oklahoman*, December 23, 2006, 1A, 3A.

Lee, R.E. "1907 Forty Tickets on Sale." *Oklahoman*, September 26, 1994, 65.

———. "Sidewalk Too Narrow Along Canal." *Oklahoman*, August 8, 1999, C-1.

———. "Trivialities Involving Oklahoma, Global Geography." *Oklahoman*, September 10, 1999, C-1.

Medley, R. "After Half Century, Charcoal Oven Owner Says He's Having Too Much Fun to Sell." *Oklahoman*, August 9, 2008, B-1, 6.

———. "Memories of the Big Pig Live On." *Oklahoman*, November 24, 2010, 13-A.

Miller, L. "City Couple's Drive-In Grows into $8 Million-a-Year Chain." *Oklahoman*, October 25, 1981, 7-C.

Nichols, M. "Employees Provided Special Feeling at Anna Maude." *Journal Record*, October 11, 1986.

———. "Samara Made a Living on Always Trying Something New." *Journal Record*, December 21, 2001.

Oklahoman. Advertisement. December 28, 1928, 11.

———. "Stock Yards Bank's History Colorful." March 24, 1985.

Owen, P. "Split-T: Memories Hot Off Grill Eatery Shuts Doors on Era." *Oklahoman*, October 25, 1993, A-1, 6.

Pemberton, T. "Del Rancho Continues to Expand." *Oklahoman*, April 26, 2005, 3-B.

Posey, E. "Chinese Seeks Roots, Answers in City." *Oklahoman*, June 8, 1984, 74.

BIBLIOGRAPHY

Reports, S. "Cafeteria Relocation Upheld." *Daily Oklahoman*, April 23, 1976, 18.

———. "City Briefs." *Oklahoman*, Feburary 15, 1939, 2.

———. "Executive Hurt in Lake Mishap." *Oklahoman*, August 5, 1960, 3.

———. "Former Restaurant Owner Dies." *Oklahoman*, October 29, 2007.

———. "Variety Spices Pizza Offerings." *Orbit*, October 9, 1977, 224.

Singer, Mark. *Funny Money.* New York: Houghton Mifflin Harcourt, 2004.

Sutter, E. "Cafe's Owner Marks 40th Year in Business." *Oklahoman*, February 19, 1986, 71.

Taylor, J. Nelson. "Margaret Pearson Cleared of Killing." *Daily Oklahoman*, November 15, 1963.

Victor, J. "Anna Maude Celebrates a Tradition She Founded." *Sunday Oklahoman*, July 16, 1978, 12–13.

Zeaman, J. "Kaiser Tradition Continues." *Daily Oklahoman*, August 19, 1973, 9-B, 10-B.

INDEX

A

Abney, Hank 88
Abney, Margaret 88
Abrahamsen, Hans 34
Across the Street 123, 124
Adair, Gerald 58
Adair, Glen 58
Adair, Jim 58
Adair, Ralph 58
Adair's Cafeteria 58
Adair's Tropical Cafeteria 58
Adams, Dub 33
Aita, Cesar "Nino" 163
Aloha Garden 137
Alvarado, Luis 38, 43, 71, 73, 121,
 138, 163, 164
Alvarado, Maria 138
American Café 40
Anderson, Kyle 41, 59
Anderson, Levita. *See* Bayless, Levita
Anna Maude Cafeteria 17, 18, 62,
 101, 149
Ann's Chicken Fry House 145
Applewood's 143, 144, 154
Ashcraft, Michael 155
August Moon 137

B

Back Door Barbecue 158
Baggett, Herman 35, 43
Barrientos, Frances 71
Bayless, Levita 83
Bayless, Rick 83, 85, 87, 113, 125
Bayless, Skip 85
Beacon Club 66
Beard, James 108
Becker, Chris 169
Beckloff, Lisa 153
Bennai, Nordeen 51
Bennett, John 13, 111, 112, 114, 147
Beverly's Drive-In 25, 67, 68, 77
Beverly's Gridiron 67
Beverly's Grill 25, 26, 67, 97
Beverly's Hideaway 67
Big Bev Burger 69
Big Ed's 131, 132
Big Truck Tacos 158
Bill Kamp's Meat Market 31
Bishop's Restaurant 21, 35, 58, 101
Bixler's 91
Bleakley, Bill 155
Bleakley, Chad 169
Bobby McGee's Conglomeration 127

INDEX

Bob's Pig Shop 33
Bolen, Nelson 169
Bonadio, Bill, Jr. 135
Bonadio, Bill, Sr. 135
Bonaparte's Drive-In 127
Boston, Melvin 50
Boudreaux, Henry 169
Boulevard Cafeteria 63, 64
Boylan, Patrick 107
Britling Cafeteria 20
Broadway Drive-Inn 92
Brown Bag Deli 117
Brown, Maggie 62
Burchett, Alvin 145
Burrus, Lee 170
Buthion, Alain 156, 161, 162
Buthion, Michel 156, 161
Byrd, Tommy 170

C

Cabrera, Cindy 138
Café 501 51, 124, 148
Café do Brasil 139
Campus Corner 32, 124
Canton Chinese Restaurant 137
Cappuccino's 156
Captain's Table, the 78
Carp's 92
Casa Bonita 139, 140
Casa Juanito 74
Cattlemen's Café 39, 41, 48, 151
Cattlemen's Steakhouse 39, 151, 153
Cellar Restaurant, the 108, 157
Chandelle Club 62, 124
Charcoal Oven 92, 94, 95
Charlie Newton's 41
Cherry's 92
Chicago's 123
Chicas Mexican Cafe 98
Chicken in the Rough 25, 67
Child, Julia 13, 111, 112
Choi, Sam 36
Chow's Chinese Restaurant 137
Christopher's Restaurant 113, 116, 153

City Bites 169
Classen Cafeteria 54, 165
Classen Grill 124, 147, 148
Coach House, the 155, 156, 157, 158
Cocina De Mino 138
Coit's 91, 96
Collins, Mae 50
Colonial Bakery Plant 32
Comeback Sauce 28
Coney Island Hot Dogs 16
Coq d'Or 122
Cory, Kristen 15
Crosstimbers 58, 125, 159, 160
Crump, Arthur 20
Cruz, Manuel 73
Crystal's Pizza & Spaghetti 140
Cuellar, Gilbert 38
Cuellar, Willie Jack 38, 73
Cummings, Sean 170
Curry, Dot 77

D

Dakota's 123
Dansereau, Kim 15, 170
Davis, Ana 139
Davis, E.J. "Catfish" 106
Deep Fork 41, 157
Delmonico Restaurant 34
Del Rancho 92, 95, 96
Denham, Pat 64
Der Dutchman 128
Dermer, Richard 79
Desjarlais, Taylor 171
Dodson, Charles 57
Dodson, Charlotte 59
Dodson, Joe 59
Dodson's Cafeteria 59
Dolores Restaurant 27, 28
Don Serapio's 74
Dot Wo 166
Dunham, Marc 169
Durant, Kevin 125

INDEX

E

Eagle's Nest, the 123, 124
Earl's Rib Palace 157
Eaves, Alleene 88
Eaves, Glen 88
Eckles, Loreta 97
Eckles, Vern 97
Éclair, the 90
Egan, David 94, 143, 144
El Charrito 71, 73, 121, 138, 139, 163
El Charro 38, 43, 71, 73
El Chico 71, 73, 138, 139
Elemental Coffee 171
El Fenix 38, 74
Elias, Chris 118
Elias, Eddy 118
Elias, Jim 116
El Patio 71
El Rancho Sanchez 73, 74, 139
El Zocalo 123
Empie, Bob 39
Empire Slice House 171
Eng, Roger 37
Erixon, Eula 49, 50
Erixon, Gustave 49, 50

F

Falkner, Clay 171
Fiaccone, Shaun 15, 170
Fleischfresser, Kurt 127
Fleming, Jo 50
Flying Chicken 92
Fong, George 137
Forrest Pruitt 163
Frey, Hank 41, 45
Fung's Kitchen 166

G

Gabriella's Italian Grill and Pizzeria 41
Gandy Pickle Company 33
Garage Burgers and Grill, the 125
Garcia, Marcelino "Chelino" 164
Garland's Drive-In 91

Gawey, Greg 114, 117
Geist, Bill 54, 61
Geist, Jim 61
Geist, John 61
Geist, Ralph 53, 55, 57, 61, 92
Gideo, Candace 137
Giggers, Randy 15
Glen's Hik'ry Inn 87
Golden Pheasant 137
Golden Phoenix 166
Gonzalez, Julian 163
Goode's 92
Goody-Goody Barbeque 28
Goro Ramen + Izakaya 171
Grand House Asian Bistro 165
Grateful Bean, the 15
Gray, Ken 35
Gray, Susie 35
Great American Railroad Co., the 126
Groth, Jonathan 171
Ground Floor Café, 157

H

Habana Club 118
Haley, Karen 34
Hamburger Spot, the 95
Hammons, Bob 33
Hank Kraft 125
Hank's Hik'ry Pit 90
Harry Bear's 123
Haynes, David 41
Haynes, Johnnie 130
Haynes, Rick 41, 129, 130
Hefner Grill, the 125
Henderson, Phil 33
Herman's Seafood 34, 43, 123
Hernandez, Leticia 139
Hernandez, Mino 138
Hickory House 83, 85, 86, 87, 147
Hideaway Pizza 79
Hightower, Dannie Bea 108
Hightower, Frank 108, 111, 112
Hilger, Rusty 93
Hines, Duncan 28

Hodges, Jim 126
Holland, Sophia 153
Hollies Drive-In 93
Holloway, Peter 124, 148
Homsey, Mickey 65
Huckins Hotel 101
Hunan 137
Hungry Peddler, the 123, 124
Hunt's Waffle Shop 22

I

Iguana Lounge 157
Ingrid's Kitchen 170
Interurban Eating House, the 146
Irma's Burger Shack 157

J

Jack's Happy Days Grill 78
Jack Sussy's 74, 77, 78, 106, 135
Jake's Cowshed 76
Jamboree Supper Club 76
Jamil's Steakhouse 114, 116, 117, 118
Jazzar, Johnny 161
Jazzar, Nora 161
J.B. Nimble's Ice Cream Parlor 124
J. Bruner's 108
Jerry Wood 116
Jimmy's Egg 148
Jim Vallion 121, 122
J. Isaac Grundy's, 123
J.L. Wyatt Grocery 31
Johnnie's Charcoal Broiler 41, 87,
 129, 130
Johnson, Cally 158
Johnson, Russ 169
Junior's 118, 119, 120

K

Kaiser, Gladys 14
Kaiser's Ice Cream 13
Kamp Brothers Market 31
Kamp's 1910 Café 31
Katz Drug Store 100
Keith, Toby 125

Kemp, Florence 99
Kentucky Club 41
Khouri, Rudy 161, 162
Kingman Café 36, 37
King, Vidaree 107, 108
Kliewer, Bruce 52
Krell, Jonathan 169
Kyle's 1024 41

L

Ladd, Darryl 117
Lady Classen Cafeteria 57, 61
Larry Burke 15
Larry Wood 116
Le, Kim 148
Le, Loc 148
Leo's Barbecue 113, 147
Les Caveaux 155
Loeffler, Rusty 146
Lottinvilles Wood Grill 148
Lower, Chris 58, 87, 114, 116, 155
Lower, Laveryl 158
Luby's Cafeteria 20, 59, 61
Ludivine 169
Lunch Box, the 65
Luper, Clara 98, 99, 100
Lyon, Beth Ann 171
Lyon, Cooper 19, 62
Lyons, Connie 107

M

Magic Time Machine, the 127
Mahogany 125
Mainey's 92
Mama Roja 125
Mamasita's 15
Mandarin Chinese and American 137
Marks, Steve 52
Marlow's 92
Marneres, Tony 41
Marsh, Hubert 32
Marsh's Drive-In 33, 92
Martin Carriker 105
Masoudy, Renee 70

Mathis, Kathryn 158
Mayfield, Johnny 98
McNellie's Pub 171
Meadows, Janie Sanchez 74
Meadows, Jim 74
Metro Wine Bar and Bistro, the 156, 157
Michaelis Cafeteria 20
Michael's Plum 66, 149
Mihas, Bill 16
Minnie's 75
Miskovsky, George 105
Molly Murphy's House of Fine
 Repute 127
Montrachet 157
Mr. Bill's 58
Mule, the 171
Murcer, Bobby 41
Mutt's Amazing Hot Dogs 158
Muzio, Houston 52

N

Ned's Grill 82
Ned's Steakhouse 82
Neptune Submarine Sandwiches 134
Newport, the 155
Nguyen, Vuong 171
Nicholas, Justin 170
Nichols Hills 15, 41, 98, 117, 119, 155
Nickles, Don 153
Nicolosi's 79, 81, 135
Nic's Grill 170
Nino's Mexican Restaurant 127
Nomad, the 77, 79
Nonna's Ristorante 131
Novak, Leo 171

O

Ogle, Bob 30
O'Hair, Larry 149
Oklahoma County Line, the 41
O'Mealey, Naomi 54, 57, 59, 74
O'Mealey's Cafeteria 57
O'Neill, Chad 93
Osborne, Beverly 22

Osborne, Rubye Massey 23
Osborne's Waffle House 22

P

Packingtown 39
Pancho's Mexican Buffet 139
Papahronis, Aristotle "Johnny" 66
Papahronis, John B. 65
Papa's Little Italy 137
Parrott, Ryan 170
Partain, Josh 171
Paschal, Pete 31, 32
Paseo Arts District 79
Patio, the 97
Paul, C.V. 41
Paul, Keith and Heather 170
Pearl's Oyster Bar 159, 160
Pearson, Margaret 105
Peccio, Frank 75
Pelican Pete's 123
Penn Square Bank 119, 124, 145
Penn Square Shopping Center 95
Pepperoni Grill 52, 123
Peppers, Charles 155
Pete's Barbecue 31
Pete's Place 75
Petroleum Club 65, 66
Phillips, Malin Schroer 65
Pho Lien Hoa 166
Picasso's Café 15
Pie Junkie 171
Pig Stand 27, 32, 33, 92
Pistachio's 66
Pizzeria Gusto 158
Platter's 123
Portobello 157
Potter's 91, 130

Q

Quick's Drive-In 91, 94, 134

R

Ramirez, Tulio 139
Ramsey, Warren 18, 108

Ranch Steakhouse, the 127
Rector, Debbie 153
Red Eagle Room 122
RedRock Canyon Grille 125
Reuben Rugby's 123
R&J Lounge 171
Roach, Mary Marsh 32
Roosevelt Grill, the 149, 155
Ross, Robert 146
Roxy's Ice Cream 171
Royer, Joseph 171

S

Saigon Baguette 166
Saints Irish Pub 171
Samara, Jake 76, 79
Samara, Mike 77
Sanchez, John 74
Sanchez, Serapio 74
Sanchez, Terry 90
Sanders, Harland 67
S&B Burger Joint 171
Schaffer, Peter 15
Schroer, Bill 65
Schroer, John, Jr. 63
Schroer, John, Sr. 57
Scothorn, Chad 124
Seikel, Paul 93
Shaw, Randy 26, 67
Shepherd Mall 73, 122, 127
Sheung, Michael 137
Shipman's Restaurant 98
Shogun Steak House of Japan 166
Shorty Smalls 123
Shumate, Bill 160
Shumsky, Jim 119, 120
Sidewalk Café 123
Silver Palm Room 122
Simon, Ingrid 170
Simon, Junior 118, 120
Skirvin Hotel 101, 113, 149, 156
Sleepy Hollow 49, 50, 52
Smelser, Gene 35, 121, 124
Smelser, Jim 52

Smirlis, Dimitrios 16
Smith, Anna Maude 17, 18, 19, 43,
 53, 57, 62, 108
Smith, Bob 53, 61, 62, 63, 64
Smith, Charles 147
Smith, Eric 169
Someplace Else Deli 134
Sonic Drive-In 92, 93
Soter, James 16
Spaghetti Factory 79
Speegle, Harlan 98
Spitler, Greg 170
Split-T, the 92, 93, 101
Steckler, Bob 90
Steckler, Lola 90
Stella Modern Italian 171
Stephens, Amanda 27, 28, 92
Stephens, Dolores 27
Stephens, Ralph 27, 32
Stephens, Rober 27
Stephens, Vince 27, 92
St. George Greek Orthodox Church 32
Stock Yards Bank, the 39
Stockyards City 39, 151, 153
Stoops, Bob 125
Stranger, Jonathon 169
Strawn, Ed 66
Stubbs, Dick 47, 94, 143, 151
Sullivan, Bob 78, 149
Super Cao Nguyen Market 166
Sushi Neko 167
Sussman, Jack 76, 77, 78
Szechuan Bistro 166

T

Taco Mayo 141
Tamashii Ramen 171
Tayar, Bob 127
Tayar, Jeffiee 127
Ted's Cafe Escondido 125
Tello, Jesus 73
Texanna Red's 123
Thibault, Art 106, 107
Thibault, Marian 105, 108

INDEX

Thomas, Ed 131
Thomas, Jennie 131
Thomas, Nicole 131
Tien, Kathy 165
Tien, Thai 165
Tokyo Japanese Restaurant 167
Tom's Barbecue 87
Tony's Italian Specialties 135
Tony's Via Roma 81
Tower, the 92
Town Tavern, the 53, 57, 64, 92
Triple's 123
Tulio's Mexican Cafe 139

U

United Founders Tower 62, 124
Upper Crust Wood-Fired Pizza 125
Uselton, Angie 15

V

Valentine, Josh 171
Valentine's 92
Val Gene and Associates 35
Valgene's Cafeteria 122
Vallion, Jim 35, 124
Vallion, Maggie 35
Van's Café 41
Van Stolk, Martin David 124
Vast 158
Velvet Dove, the 145, 151
Vic & Honey's 43
Vincent, Brad 93
Vito's Ristorante 170
VZD's 169

W

Wade, Gene 45, 47, 48, 151
Wade, Norma 45
Wade, Percy, Jr. 45
Wade, Percy, Sr. 41, 45
Walton, J.C. 32
Waugh, Bill 139
Western Concepts 158, 167
Wood's 92

Y

York, Edna 49, 50
Yukon Mining Co. 124
YWCA 17, 18, 53

Z

Zamudio, Francisco 140
Zamudio's 140
Zorba's Mediterranean Restaurant 51
Zuider Zee 128

ABOUT THE AUTHOR

Dave Cathey has been food editor and written The Food Dude column for the *Oklahoman* since 2008. In more than twenty-five years at the *Oklahoman*, he has served as state editor, assistant city editor and television columnist. This is his second book for Arcadia/The History Press. The first was *A Culinary History of Pittsburg County: Little Italy, Choctaw Beer and Lamb Fries* (2013). He and his wife, Lori, have two children, Luke and Kate.